HANGJIA
DAINIXUAN

行家带你选

玛 瑙

姚江波 ／ 著

中国林业出版社

图书在版编目 (CIP) 数据

玛瑙／姚江波著. - 北京：中国林业出版社，2019.6
（行家带你选）
ISBN 978-7-5038-9978-2

I. ①玛… II. ①姚… III. ①玛瑙 - 鉴定 IV. ① TS933.21

中国版本图书馆 CIP 数据核字 (2019) 第 047009 号

策划编辑　徐小英
责任编辑　刘香瑞　梁翔云　徐小英
美术编辑　赵　芳　刘媚娜

出　　版　中国林业出版社(100009 北京西城区刘海胡同 7 号)
　　　　　http://www.forestry.gov.cn/lycb.html
　　　　　E-mail:forestbook@163.com　电话：(010)83143515
发　　行　中国林业出版社
设计制作　北京捷艺轩彩印制版技术有限公司
印　　刷　北京中科印刷有限公司
版　　次　2019 年 6 月第 1 版
印　　次　2019 年 6 月第 1 次
开　　本　185mm×245mm
字　　数　169 千字（插图约 360 幅）
印　　张　10
定　　价　65.00 元

战国红摆件

南红摆件

战国红玛瑙筒珠

红玛瑙卧狮·清代

◎ 前 言

　　玛瑙是一种天然玉石，其形成需要亿年时间，由隐晶质的石英组成，主要化学成分是二氧化硅，经常混合蛋白石。玛瑙硬度很大，摩氏硬度 6.5～7，比和田玉还要硬，内部结构致密，可雕可塑，是雕刻用的好材料。玛瑙颜色丰富，红色、黄色、蓝色、黑色、棕色、褐色、绿色等都有见，犹如灿烂星河。但并不是所有色彩的玛瑙都适合收藏。总体而言，玛瑙的色彩以红色为贵重，而且也不是所有红色的玛瑙都有收藏价值，主要以南红和战国红为重。南红矿料主要出产于新疆、青海、甘肃、云南、四川等地，其中以产于云南保山的一种红色玛瑙质地最为优良，色彩以柿子红为主，红色震人心魄，人们称之为"南红保山料"，保山南红在清代资源已接近枯竭，曾经作为清代达到级别官员帽子上的顶珠。另外，朝珠、佛珠、手串、鼻烟壶、如意、雕件、把件等都有见，被人们赋予了吉祥如意的寓意，人们对其趋之如鹜，特别是当代人们更是情有独钟。保山南红的价格一浪高过一浪，但保山南红毕竟太少了，客观上显然不能满足人们的需要。在这一背景之下，人们寻找了与保山南红十分相似的"南红凉山料"作为替代品，受到人们的青睐。其色彩同样以柿子红最为贵重，紫红、橙黄、玫瑰红、血红等色彩也都有见，晶莹剔透，分外妖娆，南红凉山料风靡当代中国，成为收藏市场上的新宠。与此同时北方地区也出现了一种与南红色彩、纹理均不同，有着绮丽纹理的红色玛瑙。由于其色彩相互拼斗，争奇斗艳，人们称之为"战国红"，亦指因类似战国时期出土玛瑙的色彩，其本质是一种红缟玛瑙，多呈放射型色带状，主要产地为辽宁朝阳北票和河北宣化一带，虽发现时间不长，但在市场上已是十分鼎盛。我国早在新石器时代就有玛瑙的使用，夏商周奴隶社会、秦汉至明清封建社会中都有使用，是珍贵的珠宝和人们的饰品。由于当时人们的开采能力

南红凉山料摆件

红玛瑙珠链·西周

有限，红色玛瑙很少见，但红色在高古时期显然已是人们喜爱的色彩，如西周时期虢国墓地虢文公墓内出土的众多由玛瑙珠穿系而成大型玉组佩当中的红玛瑙，多系焙烧而成，可见当时人们对红玛瑙的钟爱。秦汉以降，直至明清，目前玛瑙已经成为天然玉石当中的重要门类。在南红和战国红玛瑙之外，玛瑙的种类非常多，已知的种类达数百种，如马达加斯加玛瑙等。玛瑙产地也非常多，世界上很多国家都产，如中国、美国、巴西、埃及、澳大利亚、墨西哥、巴西等都盛产玛瑙；国内如湖北、河南、陕西、辽宁、陕西、安徽、甘肃、台湾、新疆、内蒙古等地也盛产玛瑙。由此可见，玛瑙的种类非常多，但不是所有的玛瑙都适合收藏，只有宝石级的玛瑙具有较高的收藏价值。

　　中国古代玛瑙虽然离我们远去，但人们对它的记忆是深刻的，这一点反应在收藏市场之上。在收藏市场上历代玛瑙受到了人们的热捧，各种古代玛瑙在市场上都有交易，特别是明清玛瑙在拍卖行经常可以看到其身影，如串珠、项链、山子、平安扣、念珠、胸针、笔舔、炉、印章、瓶、供器、狮、虎、臂搁、佛珠、水盂、吊坠、如意、桃子等都有见，可谓是造型繁多。南红也由旧时的堂前燕，今日飞入百姓家，所以从客观上看收藏到古代玛瑙的可能性比较大。当代玛瑙数量众多，特别是南红凉山料和战国红的发现为人们提供了新材质，人们对其趋之如鹜，如今已是以克论价，优者数万，但在暴利的趋势下，也注定了各种各样伪的玛瑙频出，成为市场上的鸡肋。高仿品与低仿品同在，鱼龙混杂，真伪难辨，玛瑙的鉴定成为一大难题。而本书以文物鉴定角度出发，力求将错综复杂的问题简单化，以种类、质地、造型、纹饰、色彩、光泽、重量、工艺等鉴定要素为切入点，具体而细微地指导收藏爱好者由一件玛瑙的细部去鉴别古玛瑙之真假、评估古玛瑙之价值，力求做到使藏友读后由外行变成内行，真正领悟收藏，从收藏中受益。以上是本书所要坚持的，但一种信念再强烈，也不免会有缺陷，希望不妥之处，大家给予无私的批评和帮助。

姚江波

2019 年 5 月

◎ 目 录

南红手链·当代四川凉山美姑九口料

绿玛瑙摆件

水草花玛瑙镯（三维复原色彩图）

水草花玛瑙筒珠

南红凉山料算珠

战国红摆件

战国红执壶（三维复原色彩图）

第一节 概 述

一、概 念

玛瑙是一种天然玉石，它的基本矿物组成
是石英，主要化学成分是二氧化硅，由隐晶质
的石英组成，经常混合有蛋白石，有时体内形成
条纹带，颜色鲜艳，质地坚硬。原石多呈现出扁
圆形、不规则块状等，颜色丰富，红、黄、蓝、黑、棕、褐、绿等
色彩及衍生性色彩都有见，纯色少见，且珍贵，主要以渐变色彩为主。
玛瑙在新石器时代就有使用，夏商周奴隶社会、秦汉至明清的封建
社会中都有使用，是珍贵的珠宝。民国及当代，人们对其更是钟爱，
目前玛瑙已经成为天然玉石当中的重要门类。

绿玛瑙摆件

南红凉山料摆件

马达加斯加玛瑙执壶（三维复原色彩图）

二、产 地

　　玛瑙国内和国外都有产，产地总的来看比较丰富。国内著名的产地，如湖北、河南、陕西、辽宁、安徽、甘肃、台湾、新疆、内蒙古等地都盛产。这些地区的产量一般都比较大，品种基本齐全，所以玛瑙料进口不像琥珀那样的多，多是以国内料为主。当然国外盛产玛瑙的国家和地区也有很多，如美国著名的黄石公园就产玛瑙，埃及、澳大利亚、墨西哥、巴西等国也都盛产玛瑙。因此，玛瑙从矿藏上看，应该不属于量特别小的天然玉石矿，只是在品级上差别比较大，这一点我们在鉴定时应注意了解。

马达加斯加白玛瑙平安扣

南红凉山料圆珠

马达加斯加红玛瑙籽料摆件

第一章 质地鉴定

第一节 概 述

一、概 念

玛瑙是一种天然玉石，它的基本矿物组成是石英，主要化学成分是二氧化硅，由隐晶质的石英组成，经常混合有蛋白石，有时体内形成条纹带，颜色鲜艳，质地坚硬。原石多呈现出扁圆形、不规则块状等，颜色丰富，红、黄、蓝、黑、棕、褐、绿等色彩及衍生性色彩都有见，纯色少见，且珍贵，主要以渐变色彩为主。玛瑙在新石器时代就有使用，夏商周奴隶社会、秦汉至明清的封建社会中都有使用，是珍贵的珠宝。民国及当代，人们对其更是钟爱，目前玛瑙已经成为天然玉石当中的重要门类。

绿玛瑙摆件

南红凉山料摆件

二、产 地

马达加斯加玛瑙执壶（三维复原色彩图）

　　玛瑙国内和国外都有产，产地总的来看比较丰富。国内著名的产地，如湖北、河南、陕西、辽宁、安徽、甘肃、台湾、新疆、内蒙古等地都盛产。这些地区的产量一般都比较大，品种基本齐全，所以玛瑙料进口不像琥珀那样的多，多是以国内料为主。当然国外盛产玛瑙的国家和地区也有很多，如美国著名的黄石公园就产玛瑙，埃及、澳大利亚、墨西哥、巴西等国也都盛产玛瑙。因此，玛瑙从矿藏上看，应该不属于量特别小的天然玉石矿，只是在品级上差别比较大，这一点我们在鉴定时应注意了解。

马达加斯加白玛瑙平安扣

南红凉山料圆珠

马达加斯加红玛瑙籽料摆件

绿玛瑙摆件

绿玛瑙摆件

六、温　度

玛瑙由于结构很稳定，且相当致密，所以玛瑙的温度变化也比较小。因此就形成了冬天暖和，夏天凉的温度特征。实际上，这种特征不是由于玛瑙的温度变了，而是由于我们自身对于外界温度的感受变了。这也是鉴定玛瑙的重要依据。

七、脆　性

玛瑙的脆性特征很大。大多数玛瑙原石是有破损的，而且棱角尖利，一看就是傲骨嶙峋、宁折不弯所造成的伤痕。由此可见，其脆性很大，这是由于其硬度相当大所造成的。因此，对于玛瑙制品要特别保护，不然一旦磕碰很有可能就会粉身碎骨。

黑玛瑙摆件

红玛瑙摆件

南红凉山料摆件

南红凉山料摆件

红玛瑙摆件

四、皮色

　　玛瑙原石多数皮色都较重，如较为贵重的南红和战国红都有很重的皮色。南红就像是红薯刚从地里挖出来一样，坑洼不平，战国红则是像土豆，皮壳也是较重。有很多赌石的人常相信皮壳与内部质地的关联，当然不否认有着某种关联，但这种经验性东西不可全信，只能是参考，不然就不是赌石了。

五、横截面

　　玛瑙的横截面是鉴定玛瑙的重要标志。一般情况下，横截面都有同心圆波纹。这种波纹由内向外扩展，鉴定时应注意分辨。

红玛瑙摆件

南红凉山料手链

二、密 度

玛瑙的质地致密，密度 2.41 ～ 2.78 克／立方厘米，这个密度数值相当的高，对于我们鉴定玛瑙非常重要。只要我们检测数值，真伪立现。

三、折射率

折射率是光通过空气的传播速度和光在矿物中的传播速度之比。通常，玛瑙的折射率为 1.52 ～ 1.54。对于被鉴定的某件玛瑙制品来讲，显然折射率是个固定数值，将这个固定数值同玛瑙应有的数值进行对比，显然就可以知道被鉴定玛瑙是否属于真的玛瑙制品，鉴定时应注意使用。

战国红摆件

战国红摆件

第二节 质地鉴定

一、硬 度

　　硬度是矿物抵抗外来机械作
用的能力，如雕刻、打磨等，是自
身固有的特征，同时也是玛瑙鉴定的
重要标准。通常玛瑙的摩氏硬度 6.5 ～ 7。这

内蒙古阿拉善戈壁玛瑙摆件

个硬度非常的大，甚至比和田玉的硬度还要大，可见玛瑙在天然玉
石当中硬度是非常大的。当然，这个硬度非常适合于雕刻，具有可
雕可塑性，特别是对于当代机雕而言更是这样。但古代在雕刻玛瑙
时往往出现一些困难，这一点从有的线条比较生硬上就可以看出来。
由于玛瑙硬度大，所以手工雕刻还是有一定的困难。

南红凉山料圆珠

南红凉山料算珠

战国红筒珠

战国红摆件

四、战国红

　　战国红是产自北方地区的一种红缟玛瑙，因类似战国时期出土玛瑙的色彩，亦指其本身色彩斑斓，多呈放射色带状，争奇斗艳，顾名思义称之为战国红。战国红玛瑙主要产地为辽宁朝阳北票和河北宣化一带，这几年发现很多地方也产这种红缟玛瑙。战国红玛瑙发现时间不长，但市场反应比较好，究竟能否像保山南红料一样风靡收藏界还需要历史的检验。

战国红摆件

南红凉山料摆件

南红云南保山杨柳料

南红凉山料算珠

三、南 红

　　南红是玛瑙中的稀有品种，也是十分贵重的玛瑙。这种玛瑙以红色为基调，晶莹剔透，分外妖娆，为人们所喜爱，目前是以克论价。矿料主要出产于云南、四川、甘肃、新疆、青海等地。主要以云南保山料和四川凉山料为贵重，色彩以柿子红最为贵重，紫红、橙黄、玫瑰红、血红等色彩也都有见。南红是目前玛瑙市场上的主流。

南红凉山料摆件

战国红筒珠

战国红镯（三维复原色彩图）

十、条 带

　　玛瑙中基本都有条带状的纹理，这是由玛瑙固有的特性所决定的。这种条带状的纹理有轻重之分：有的特别轻微，如特别好的南红料；有的则是非常的明显。但无论怎样，必然有见这种纹理，因为不然就有玉髓之嫌。这一点我们在鉴定时应注意分辨。

水草花玛瑙筒珠

南红凉山料摆件

南红凉山料摆件

南红凉山料摆件

战国红筒珠

南红凉山料算珠

南红凉山料算珠

马达加斯加白玛瑙筒珠

十一、光　泽

光泽是光线在物体表面反射光的能力。玛瑙的这种反射能力非常强，玻璃光泽，光亮度好，而且油性也比较好。多数玛瑙通体闪烁着非金属的油脂光泽，非常的漂亮，柔和细腻、熠熠生辉，鉴定时应注意分辨。

十二、透明度

透明度是矿物透过可见光的程度。玛瑙透光的能力比较复杂：多数是微透明；色彩黯淡者透光性差，如黑玛瑙、棕褐色的玛瑙等；白玛瑙、红玛瑙等色彩浅淡的玛瑙透光性强；有些品质较高的南红玛瑙透光性非常强。当然影响玛瑙透明度的因素有很多，如厚度等都会影响，厚度越大，透明度越低，这是很正常的自然现象，这些因素我们在鉴定时应引起充分注意。

南红凉山料圆珠

南红凉山料圆珠

南红凉山料算珠

战国红筒珠

十三、吸附效应

吸附效应鉴定的原理，利用的是自然界天然玉石的一种物理现象，即热电效应。加热玛瑙所产生的电压能够吸附灰尘，而人工合成者则不会有这一物理现象，自然可以洞穿真伪。通常情况下不用特意加热，玻璃柜内灯光的热度足以，它已经可以使玛瑙体两端受热，从而产生电荷，进而吸附灰尘等细小颗粒，但对于玛瑙而言这种吸附效应，需要仔细的观测，鉴定时应注意使用。

南红凉山料碟（三维复原色彩图）

战国红执壶（三维复原色彩图）

十四、手 感

　　人们用手触及到玛瑙时的感觉也是鉴定的重要标准，这种标准大有"只可意会，不可言传"之韵。玛瑙由于密度很大，结构致密，所以手感会比较重；且在温度上不易变化，不会有忽冷忽热的感觉，触摸是冰凉的感觉。从温润性上看，玛瑙通常十分细腻、温润、光滑。手感虽然是一种感觉，但它却不是唯心的，它也是一种科学的鉴定方法，而且是最高境界的鉴定方法之一。收藏者在练习这种鉴定方法时需要具备一定的先决条件，就是所触及的玛瑙必须是靠谱的标准器。如果是伪器则刚好适得其反，将伪的鉴定要点铭记心中，为以后的鉴定失误埋下了伏笔，这一点我们应引以为鉴。

绿玛瑙摆件

南红凉山料圆珠

战国红摆件

战国红摆件

十五、纯净程度

　　玛瑙的纯净程度是判断优劣最重要标准之一。通常情况下，玛瑙不是很纯净，包括南红都是这样，只有比较好的料子，我们的视觉才能感觉不到杂质的存在。事实上，杂质是不可避免的，任何玛瑙理论上都有杂质，只是轻微与严重之分。但只要我们的视觉感觉不到，对于只是作为艺术品的玛瑙而言这就是通体匀净，这一点我们在鉴定时应注意分辨。

红玛瑙镯（三维复原色彩图）

战国红珠（三维复原色彩图）

十六、精致程度

　　玛瑙在精致程度上比较复杂，无论是古代还是当代的作品中，精致、普通、粗糙者都有见。但显然其主要功能为陈设装饰、把玩等，所以基本上还是以精致为主，普通和粗糙者少见。玛瑙的精致程度与玛瑙的品类有关，如南红在精致程度上主要就是以精致为主，粗糙者几乎不见，这一点我们应注意分辨。玛瑙的精致程度还与色彩有密切关联，再就是与原料的品级也有密切关联。总之，就是原料越优良，其精致程度一般情况下就会越精致。

红玛瑙、和田玉组合手串

南红凉山料算珠

战国红筒珠

南红凉山料算珠

黑玛瑙镯（三维复原色彩图）

第三节 辨伪方法

　　玛瑙的辨伪方法主要包括两种：一种是对古代玛瑙是否是文物的辨伪，包括断时代；另外一种是对当代玛瑙质地的辨伪，主要是辨别其质地。但其实方法是人们用来达到玛瑙辨伪目的手段的总合，因此辨伪方法并不具体。它只能用于指导我们对玛瑙辨伪的一系列思维和实践活动，并由此选择采取具体的方法。由上可见，在鉴定时我们要注意到辨伪方法在宏观和微观上的区别，注意使用多种方法解决问题。

战国红隔片

红玛瑙摆件

红玛瑙摆件

一、刻画法

　　这是一种有损的检测方法。由于玛瑙的硬度很高，所以用普通的刀很难刻动玛瑙。普通的刀刻画几乎不会留下伤痕，而能留下伤痕者是伪玛瑙。而反过来，用玛瑙锋利的断口划玻璃等可以划得动，鉴定时应注意分辨。

绿玛瑙摆件

绿玛瑙摆件

马达加斯加红玛瑙籽料摆件

南红凉山料摆件

二、仪器检测

在玛瑙的辨伪当中，科学检测显然已经成为一种风尚。许多玛瑙制品本身就带有国检证书，表明仪器检测的观念已深入人心，这是由玛瑙适合检测的固有优点所决定的。通过对硬度、密度、折射率等一系列的数值的检测，很快就能够科学有依据地得出被鉴定物是否是玛瑙质地。但科学检测也并不是万能的，它只能从物理性质上证明这是一件玛瑙产品，但不能辨别优劣，以及玛瑙制品的制作和使用年代等。因此，通常情况下科学检测仪器只是鉴定的第一步，确定质地，将非玛瑙类的产品排除在外。之后，再进行综合鉴定，才能最终认识这件玛瑙。

南红保山料镯（三维复原色彩图）

战国红玛瑙镯（三维复原色彩图）

第二章　玛瑙鉴定

第一节　特征鉴定

一、出土位置

玛瑙在古代就受到人们的热捧，常常是生前佩戴，死后随葬。因此，墓葬当中出土玛瑙制品的情况很常见。

我们来看一则实例，东汉玛瑙组合串饰"M5：67，摆放在头部的左侧"（广西壮族自治区文物工作队等，2003）。这件玛瑙串饰是放在头部，虽然没有直接佩戴在身上，不过我们也可以看到其在出土位置上的重要性。显然墓主人对于这件玛瑙串饰非常珍视，放在自己的枕头旁边。当然还有很多是佩戴在身上，如西周晚期虢国墓 M2001 号墓的墓主人虢文公，身份是诸侯王，身上直接佩戴着七璜联珠组合玉佩。而其中的珠主要就是红玛瑙珠子，挂于颈部达于

复原的组玉佩·西周

七璜组玉佩下半部·西周

膝下，非常的震撼。而且，从数量的组合上我们可以看到这样的大
型玉组佩往往与礼制有关。如虢文公的身份是国君，按照西周的礼
制是可以佩戴这样玛瑙联珠佩的。但只能佩戴玛瑙珠与七璜的组佩，
这与天子九鼎、诸侯七鼎的礼制相符。

　　由此，我们也可以知道，出土位置对于古代玛瑙来讲，在判定
人们所赋予它的文化内涵上有重要意义，同时对于玛瑙的贵重程度
也具有重要意义。如出土在帝王或诸侯王的墓葬当中的玛瑙，与出
土在贫民墓中的玛瑙，有的时候由于文化内涵，以及所承载的历史
信息不同，其无论是在研究价值、艺术价值、经济价值等都有很大
区别。这一点我们在鉴定时应注意分辨。

组玉佩·西周晚期

玛瑙碗（三维复原色彩图）·西周

1. 新石器时代玛瑙

新石器时代玛瑙出土位置遗址内有见。我们来看一则实例，"细石器共 12 件。包括石核、石片石器两类，石料为暗红色玛瑙和黑色燧石，以前者为多"（成都市文物考古工作队，2002）。这并不是一个孤例，而是这种情况十分普遍。再来看一则新石器时代玛瑙"玦 1 件"（广西壮族自治区文物工作队等，2003）。例子不再赘举，各地遗址出土玛瑙制品的情况可谓是成百上千例，可见玛瑙在新石器时代遗址之中常见。从出土情况来看，很多都是生产工具类，当然也有一些礼器，如钺、璜、璧等，但在数量上显然是占少数。这可能也是新石器时代玛瑙出土位置主要在遗址的重要原因。

再来看墓葬的情况，新石器时代墓葬内出土有见，但数量并不是很多。我们来看一则实例，新石器时代玛瑙"璜 1 件"（上海博物馆考古研究部，2002）。由此可见，良渚文化时期的璜是出土在墓地之内。但像这样的例子不多见，起码没有遗址多见。我们知道，良渚文化其实在时代上已经是接近新石器时代中晚期，而那个时候良渚文化有着高度发达的古拙玉器文明，璜又是纯礼器性的造型，用于祭祀，所以随葬在墓葬当中并不奇怪。但就出土位置而言，整个新石器时代大量玛瑙的出土位置是在遗址之上，而不是在墓葬之中。这也从一个侧面证明了在新石器时代人们主要是对于天地、山川等自然神和动物神灵的崇拜，而很少去崇拜祖先神灵。所以自然墓葬当中随葬玛瑙的情况也就比较少见了，特别是新石器时代早中期更是少见。这一点我们在鉴定时应能理解。

2. 商周秦汉玛瑙

商周秦汉时期玛瑙在出土位置上特征很明确，墓葬和遗址当中都有见。如商代玛瑙环"T1004③：1，厚0.5厘米"（安徽省文物考古研究所等，1999）。凌家滩遗址出土的玛瑙制品很常见，看来商代玛瑙制品在出土位置上主要还是以遗址出土为主。墓葬出土的情况有见，但是处于辅助的位置。这说明商代在自然神灵崇拜上还是有着相当的惯性延续的力量，特别是在商代早中期更是这样。

实际上，在商代中期以后，对于自然神的崇拜已经开始减弱，这从商代青铜器的纹饰上也可以看得很清楚。如"商代青铜鬲上的纹饰由云雷纹到饕餮纹的演变，实质上是青铜鬲上的主纹从无生命的几何纹变成了有生命的兽纹。这反映了在商代早期到商代中期这段不长的时间里，人们在观念上的改变，即人们的崇拜从崇拜自然界的雷电、云雾转向对猛兽的崇拜。而出现这种现象的原因无疑是在商代生产力水平的提高，人们征服自然的能力增强，所以，就降低了对自然界神灵的崇拜。而在这时，人们经常遇到的则是猛兽，在猛兽更多威胁人类的时代，人们自然会将更多的注意力转向了对猛兽的关注上。于是就产生了对动物神的崇拜，并且使人类的崇拜从自然神崇拜的时代逐渐过渡到了动物神崇拜时代。而商代早期到商代中期青铜鬲主纹的变化就是人们这种观念转变的生动体现，同时也是支持这一说法的重要证据"（姚江波，2009）。玛瑙在出土位置上的演变实际上也遵从的是这一原理。

玛瑙珠、玉管组合饰件·西周　　　　组玉佩·春秋早期　　　　　　　组玉佩·西周晚期

玉项饰·春秋早期

在商代，人们的崇拜由自然神向动物神乃至向祖先神灵转变的巨变当中，商代玛瑙实际上在晚期也逐渐向墓葬明器的方向发展。商代祖先神的地位正式确立。关于这一点由于学界有很多争论，我们在这里不谈争论，只是以实物为依据，来确定一下商代玛瑙出土位置的特征。"让我们来看一个惊世的考古发现，这个发现就是美洲玛雅文明中的奥尔梅克拉文塔第四号文物玉圭铭文的出土，这组玉圭一共六件，每件玉圭上镌刻着纹饰和图案，然而令人惊奇的是，这些纹饰和图案所描述的竟然是殷代的祖先，如"第五圭：十一示土（十二宗祖）二（既社祭殷十四位先王）"。这些商人的遗物，证明了美洲的核心文明奥尔梅克文化遗址为殷人所建立（王大有等，2000）。而具研究"恰好这些玉圭的造型与殷墟妇好墓出土玉圭造型极为相似，可能为同时期的制品"。"由此可见，在商代，商人的活动范围已经相当遥远了，他们到达了今天的美洲大陆，并将这些刻有商王名号的玉圭供奉在那里，作为膜拜的对象"（姚江波，2013）。

七璜组玉佩下半部（局部）·西周

七璜组玉佩下半部·西周

　　由此可以确切地看到，商代晚期祖先神
崇拜基本上已有雏形。这样，玛瑙作为一种重
要的装饰品其主要服务的对象也逐渐由新石器
时代实用器为主转向了为祖先神灵服务，即由遗
址转向墓葬。这一点从商代晚期的一些墓葬当中
已经有所表现，如殷墟墓葬当中就发现了不少玛瑙
制品。西周时期这一趋势尤为明显，大多数的玛瑙制
品出土位置是在墓葬之中。我们来看一则实例，西周
玛瑙"璜1件"（中国社会科学院考古研究所山东工作
队，2000）。像这样的例子很多，特别是在一些诸侯级的
大墓当中，玛瑙随葬的数量惊人。如河南三门峡虢国墓当中
出土的七璜联珠组玉佩共由374件器物组成。整组玉佩分为上
下两部分，上部为玛瑙珠、玉管组合项饰；下部用玉璜、玛瑙珠和
料珠组合。上部由122件组成，1件人龙合纹玉佩、18件玉管、103
颗红玛瑙珠串联组成。其中，14件长方形玉管两两并排地分别串联
在两行玛瑙珠之间，另外7件呈现单行串联于其间。后者显然是为
了避免两行串珠分离而起约束作用。玉佩位于墓主人颈后中部，为
项饰的枢纽，展开长度约为53厘米，出土于墓主人的颈部。下部共
计252件，由7件玉璜由小到大与纵向排成双排四行对称的20件圆
形玛瑙管、117颗玛瑙管形珠、108颗菱形料珠相间串联而成。20件
玛瑙管分为10组，每2件成1组。料珠为18组，每组为6颗。玛
瑙珠分为16组，2颗、4颗、13颗不等为1组，统一作并排两行，
以青白色玉璜为主色调，兼以红、蓝二色，出土于墓主人胸及腹部（河
南省考古研究所等，1999）。由此可见，至西周时期玛瑙主要的出
土位置应该就是墓葬，并与玉器等共同组成了大型的礼器，象征权
力与等级地位。

组玉佩·西周晚期　　　　　　　　　　玉项饰·春秋早期

　　春秋战国时期，玛瑙基本上继承了西周时期的一些特点，主要是作为装饰品使用，出土地点也多是在墓葬之中。春秋战国"玛瑙坠饰1件"（青州市博物馆等，2002），　战国时期基本也是这样，我们来看一则实例：战国"玛瑙珠4件"（淄博市博物馆，1999）。由此可见，春秋战国时期玛瑙在数量和重要程度上显然已经无法与西周时期的玛瑙相媲美。这主要是由于在西周礼制崩溃之后，玛瑙不再是礼器的组件。但是，玛瑙仍然是人们喜欢的珠宝，这样虽然玛瑙在数量及诸多特征上有些弱化，却依然是墓葬当中出土频率较高的明器之一。秦汉时代也是这样，由于篇幅有限，我们就不再赘述，其实研究问题的方法是一样的，只要在鉴定时能够举一反三就可以。但是应记住，只是说在某一个时期玛瑙制品是以墓葬出土为主，而并不是说遗址之内就不会出现，只是遗址出土已经不是主流而已。鉴定时应注意分辨。

玉项饰·春秋

3. 六朝隋唐辽金玛瑙

六朝隋唐辽金时期是一个跨度非常长的时期，从墓葬发掘的情况来看，这一时期玛瑙依然是以墓葬出土为多见。我们来看一则实例，唐代"玛瑙珠1枚"（中国社会科学院考古研究所四川工作队，1998）。这件玛瑙珠的出土位置是在墓葬，实际上大多数的情况都是这样，生前佩戴之后就随身埋葬了。五代时期基本上也是这样，五代"石串饰1件"（西藏自治区山南地区文物局，2001），看来基本上延续了唐代的出土位置特征，以墓葬为主。辽代在玛瑙制品出土位置上也是以墓葬为主，我们来看一则实例，"玛瑙共2件"（中国社会科学院考古研究所内蒙古工作队，2003）。

实际上，以上实例都是随机选取的，也就是说比较容易找到，这说明玛瑙制品在六朝隋唐辽金时期出土位置特征是以墓葬为主。但遗址之上也有见，我们靠想象就可以知道玛瑙在当时就是人们喜欢的装饰品，但一般都是作为首饰放在家里，而并不是满大街都是，田野里都是。所以，这也是我们在遗址之上很少发现古代玛瑙的原因，而只有在一些特殊的遗址内才有可能发现玛瑙制品。我们来看一则实例，唐代"玛瑙珠101件"（黑龙江省文物考古研究所，2003）。由此可见，在古代的房屋遗址内的确有可能发现玛瑙制品。

总之，六朝隋唐辽金玛瑙在出土位置特征上依然是延续前代，以墓葬为主，遗址为辅。

战国红标本

红玛瑙卧狮·清

4. 宋元明清玛瑙

宋元明清时期玛瑙继续流行。在这一时期的墓葬当中，我们不断发现玛瑙。我们来看一则实例，明代玛瑙花叶形金簪"以玛瑙雕成佛手形镶嵌于簪顶"（南京市博物馆，1999）。由上例可见，人们将玛瑙制作成了各种各样的工艺品，工艺也更加复杂，由商周时期的串联为主，发展到镶嵌等多种工艺为一体。当然这一时期玛瑙的出土位置特征也是更为复杂。早期，宋元明等时期，基本上是以墓葬为主，遗址为辅，而清代由于距离现在比较近，有很多是传世下来的玛瑙制品。鉴定时应注意分辨。

5. 民国及当代玛瑙

民国时代距离我们现在更近，大量的玛瑙制品都是传世品，古玩商店内都比较常见。当代玛瑙更不存在出土地点的问题，只是产地问题而已。如南红主要产于云南保山和四川凉山等地，战国红产于河北宣化和辽宁阜新等地，鉴定时应注意分辨。

马达加斯加白玛瑙平安扣

马达加斯加红玛瑙平安扣

南红凉山料摆件

战国红摆件

南红保山杨柳料标本

二、件数特征

件数特征也就是玛瑙在各个时期数量上的特征。玛瑙在件数上的特征对于鉴定而言十分重要，可以反映出玛瑙在一定时期内流行的程度，给鉴定提供概率上的切实帮助。

战国红玛瑙执壶（三维复原色彩图）

玛瑙在件数特征上十分复杂。古代玛瑙新石器时代以遗址出土为主；商周直至元明时期都是以墓葬出土为主，遗址出土为辅；清代及民国主要以传世品为主；当代玛瑙在数量上创新高，由于开采能力的增强，可能数量是历代玛瑙之总合。但在这些数量当中，当代玛瑙在品类上有新选择，并不是倾向于普通的玛瑙，而是倾向于天然色彩极好的红玛瑙，如南红和战国红等，极重产地。总之，不同历史时期的玛瑙在件数特征及其特点上区别较大。如古代，并非是所有的墓葬当中都会出土玛瑙制品，偶见有墓葬会出土玛瑙，多是一些有身份的人随葬。我们来看一则实例，春秋战国玛瑙"24件（组）"（河北省文物研究所等，2001）。但古代随葬玛瑙的情况不都是如此之巨，有几十件之多，如东汉"玛瑙珰1件"（广西壮族自治区文物工作队，2002），这座墓葬只随葬了1件。通常情况下，墓葬出土玛瑙的数量基本上都是这样，多一些的也是几件，如3～4件等。当然也有规模特别大的，如果将单珠计算在内的话，可能有些贵族墓葬出土玛瑙的数量会达到成百上千件。总之，还是比较繁复，下面我们具体来看一下件数特征。

南红凉山料圆珠

南红凉山料摆件

红玛瑙标本

玛瑙标本

1. 新石器时代玛瑙

新石器时代玛瑙在件数特征上很明确。新石器时代玛瑙比较常见，我们来看一则实例，"玛瑙珠 47 粒"（青海省文物管理处等，1998）。由此可见，新石器时代玛瑙在数量上相当丰富，已经有见大量的玛瑙珠。但无论如何，新石器时代玛瑙已经成为一种风尚。实际上玛瑙是很早就被古人所认识，但在新石器时代早中期，玛瑙最先应该不是作为饰品在使用，而是作为一种工具或者是农具等在使用。这一点甚至在新石器时代晚期的遗址当中还可以看到。我们再看一则实例，新石器时代玛瑙"刮削器 7 件"（成都市文物考古工作队，2002）。由 7 件这个件数特征我们可以看到在新石器时代玛瑙作为工具应该是比较普遍，不过并不是所有遗址和墓葬出土数量都很多，也有见数量很少的情况。我们来看一则实例，新石器时代玛瑙"泡 1 件"（上海博物馆考古研究部，2002）。这件新石器玛瑙泡只有 1 件，可见在新石器时代玛瑙制品出土数量的确是多寡不一。再来看一则实例，新石器时代玛瑙"细石器共 12 件"（滦平县博物馆，1998）。总之，从总量上看，从现代玛瑙矿脉分布较为普遍来看，新石器时代玛瑙制品有一定的量，鉴定时应注意分辨。

玛瑙珠、玉管组合发饰·西周

2. 商周秦汉玛瑙

商周秦汉玛瑙在件数特征上特点很明确，商代玛瑙出土延续新石器时代，基本上以 1 件至几件为多，在总量上有一定的量。西周时期，玛瑙主要是以贵族墓葬出土为主。从发掘的诸侯王墓葬当中看，数百至上千件的情况都有见，但这些器物以玛瑙珠为多，多是与其他如玉器等组合成器，或者可以说是作为配件存在。独立成器的情况也有见，我们来看一则实例，玛瑙"璜 1 件"（中国社会科学院考古研究所山东工作队，2000）。由此可见，这件玛瑙是制作成了璜的造型，但这依然是比较少见的。这里的玛瑙被人们认为是玉器。这是被公认的，因为，从新石器时代我们就发现有玛瑙和玉器组合的串饰。商周时期延续了此风尚。如在河南三门峡西周虢国墓地就出土了众多的玛瑙珠（姚江波，2009）。汉代许慎《说文解字》称玉为"石之美有五德"，

红玛瑙标本

玛瑙珠（三维复原色彩图）·西周

玉串饰·西周

玉组佩饰·西周

所谓五德即指玉的五个特征，凡具温润、坚硬、细腻、绚丽、透明的美石，都被认为是玉。而我们知道，璜在西周时期是重要的礼器。玉璜始于新石器时代，距今7000～5000年的河姆渡遗址中已有发现，是一种弧形的玉器。汉代诸多文献认为半璧为璜。在西周时期重要墓葬虢国墓当中，"大量的玉璜由戚改制而成，是虢国玉璜重要特征之一。由以上文献可知，戚象征军权，虢国墓地许多大墓出土了众多的戚，说明虢国在西周初期是一个强大的军事诸侯封国。许多用玉戚改作成的玉璜，印证了虢国军事实力的强大。可见虢国玉戚和玉璜都是一种军权的象征。虢国玉戚与玉璜相比，除了形状差异外，最大的差别就是玉戚无穿孔，玉璜大多有穿孔。说明玉戚是放置于某处，而玉璜是挂于身上或其他地方。虢人把玉璜佩带在身上以示拥有军权，极有可能类似于现代军人的军衔"（姚江波，2009）。这样看来，这件玛瑙璜的出现非同小可，因为西周时期礼制是相当

严格的，这不仅说明了玛瑙在西周时期人们将其看成是玉，而且是一种很重要的玉器。以此类推，玛瑙珠玉组佩当中的玛瑙显然在地位上与玉器是同等重要，并非是作为配件存在，或者是出于从属的地位。这一点我们在鉴定时应注意分辨。玛瑙玉礼器总的来看数量还是偏少，这又说明西周时期的古人对于玉器鉴赏的能力很强。虽然他们承认玛瑙是玉，但是他们也发现了玛瑙与和田玉的区别，没有和田玉那么稳定，所以玛瑙很少独立成器。这是玛瑙最终没有竞争过来自新疆的和田玉成为玉礼器的原因。同时，这也是一个很重要的鉴定要点。如果发现新石器时代的玛瑙礼器造型，我们应该仔细观察，先辨明真伪。

春秋时期的玛瑙，由于礼制崩溃，玛瑙的发展更加转向了陈设装饰化，组合随意，比较自由。如春秋玛瑙"玉石项链1组，M3：28，玛瑙珠33粒"（山东大学考古系，1998）。可见，春秋时期的玛瑙在数量上继续保持一个高的态势，这可能是受到西周时期礼器玛瑙数量众多惯性的延续等原因。但很快这种惯性延续的力量便不能维持。我们再来看一则实例，春秋战国"玛瑙坠饰1件"（青州市博物馆等，2002）。这与西周时期贵族墓葬当中成百上千地随葬玛瑙的情况已经无法相比。像这样的例子还有很多，就不再赘述。但由此可见，在西周礼制崩溃后，玛瑙在数量上实际上呈现出的是一个急剧下降的趋势。战国时期更是这样，墓葬出土基本不见过大的数量，以1件至几件为主。我们随意来看一则实例，战国"玛瑙珠4件"（淄博市博物馆，1999）。另外，同一墓葬当中发现的玛瑙环也是1件。由此可见，战国玛瑙的数量与西周相比显然已经跌落到了极点。秦汉时期玛瑙在数量特征上基本上与前代很相似。我们来看一则实例，西汉"印章计5枚，为铜印、玛瑙印、琥珀印"（扬州博物馆等，2000）。看来作为独立器件，西汉时期的玛瑙终于向实用化迈进了一步，就是作为印章存在，实用与装饰的功能结合。但数量依然不多，与当时的铜印和琥珀印等相似。由此也可见，是将琥珀、铜质等材质与玛瑙列在一起的，可见玛瑙在西汉时期依然是相当贵重的珠宝。因为如琥珀等在当时的数量都很少，是极为珍贵的珠宝。但这个数量并不是玛瑙制品在西汉时期的唯一表现。西汉时期玛瑙实际在数量上表现也很突出，如"西汉玛瑙珠15件"

（广州市文物考古研究所，2003）。可见玛瑙珠的数量的确是比较丰富。而我们知道，早期玛瑙主要的造型就是作为玛瑙珠存在。那么西汉玛瑙珠在数量上相对其他玛瑙造型要高出许多，是否依然是在固守传统呢？回答显然是否定的。因为西汉玛瑙珠之所以多一些，主要是计量单位的问题。如果是以串珠来计算，可能以上15件的珠子刚好是一组串珠。这样，在数量上就同其他玛瑙制品基本相当了。由此看来，对于玛瑙件数特征的分析，还要注意到它所使用的计量单位。东汉时期，玛瑙在数量上的特征基本延续西汉。来看一则实例，"玛瑙耳铛1对"（广西壮族自治区文物工作队等，2003）。但像这样的例子不是很多。种种迹象表明，东汉时期玛瑙制品的件数特征有所增加。我们再来看一则实例，"组合串饰5组"（广西壮族自治区文物工作队等，2003）。可见数量是比较庞大。当然，东汉玛瑙数量的增加，显然与汉代厚葬制度的发展有关。但过多的情况不是很常见，因为东汉所谓的厚葬，典型体现的是陶质明器的增多，在玛瑙制品上可能只是有影响而已。鉴定时应注意分辨。

组玉佩·周代

<div align="right">战国红标本</div>

3.六朝隋唐辽金玛瑙

六朝隋唐辽金时期，玛瑙在件数特征上与东汉相比显然黯淡了许多。我们来看一则实例，六朝时期的"玛瑙管饰1件"（黑龙江省文物考古研究所，2003）。由此可见，六朝时期在玛瑙制品上数量比东汉减少，八九件的情况基本不见，而是以1件为多见。当然，这并不是由于玛瑙原料的开采有问题，而是与六朝时期禁止厚葬有关系。因为玛瑙硬度达到7左右，硬度很大，看似一个很普通的玛瑙珠子打磨起来费工费料，相当复杂，并不像我们现在的机器制作那样的轻松，所以玛瑙受到限制是必然的。我们再来看一则实例，六朝"玛瑙珠1件"（老河口市博物馆，1998）。可见，六朝时期玛瑙的随葬的确是受到了很大的限制。在一个墓葬当中随葬一件单珠的情况，实在是令人唏嘘不已。这是一个相当长的历史时期，玛瑙在出土数量上都很少。

隋唐时期，人们终于又一次迎来了经济的繁荣。在唐代，曾先后出现了贞观之治、开元盛世，厚葬进一步兴起，玛瑙再一次焕发了青春。我们来看一则实例，唐代"玛瑙珠101件"（黑龙江省文物考古研究所，2003）。由此可见，玛瑙在数量上的极度繁荣，同时也看到了盛唐的实力。这种现象并非孤例，而是有不少。但遗憾的是这种现象并非是盛唐玛瑙在数量特征上的主流。我们来看一件唐代玛瑙器皿，"玛瑙珠1枚"（中国社会科学院考古研究所四川工作队，1998）。这件实例与上面的实例是一个很大的数量差别，只有1件。这说明，唐代在墓葬当中依然还秉承着魏晋南北朝时期

的传统，而且这样的实例比较常见。从这一点看，唐代对于这一种传统的坚持依然很强劲。于是唐代玛瑙在数量上形成了两极化的趋势：一极是数量特别多；另外一极是数量特别少。数量特别多的一极反应了唐代的经济实力，出土再大数量的玛瑙都是可能的。数量少的一极显然是对于传统的延续。

　　五代玛瑙在数量上的特征基本延续唐代。我们来看一则实例，五代玛瑙"珠2颗"（西藏自治区山南地区文物局，2001）。可见，五代所谓延续唐代，实际上延续的是唐代玛瑙在数量特征上传统的一极。辽代玛瑙在件数特征上主要也是延续唐代，另外，受到五代的影响也比较严重。我们来看一则实例，辽代"玛瑙共2件"（中国社会科学院考古研究所内蒙古工作队，2003）。可见，辽代玛瑙在件数特征上并不是十分丰富。

战国红标本

红玛瑙卧狮·清

4. 宋元明清玛瑙

宋元时期玛瑙制品并不是非常之多。宋代墓葬出土玛瑙的数量特征基本上延续传统，变化并不大；元代基本上也是这样；而明代墓葬则是经常可以看到玛瑙的身影；清代主要以传世品为主，件数特征也是十分可观。我们来看一则实例，明代"玛瑙珠2粒"（南京市博物馆，1999）。可见明代玛瑙珠依然是比较常见，可能主要是作为手链、项链、串珠的组件。然而，明代玛瑙的辉煌绝不仅仅是传统的延续，而是极度发展了镶嵌工艺，使其成为除组合串联之外工艺的重要的一极。我们来看一则实例，明代"嵌玛瑙花叶形金簪2件"（南京市博物馆，1999）。可见玛瑙与金镶嵌在一起。清代传世品数量十分庞大，戒指、镯、炉、笔架、印章、山子、鼻烟壶等出现频率很高，造型可谓是丰富多彩、色彩斑斓。巧夺天工的微雕山子，众多的鼻烟壶等，流光溢彩，分外美丽。清代对于玛瑙的研究已经十分深刻，可以将一些色彩比较好的玛瑙以产地划分出来。在清代，南红制品已经比较常见，而且也是比较贵重。鼻烟壶等很多使用的就是南红料。但在清代还没有我们现在南红分得那么细。如南红保山料和凉山料，当然战国红的概念还没有，通常情况下多是云南保山料。由此可见，清代对于玛瑙的研究和区分趋于细致化，而显然这一细致化的特征影响十分深远。直至今天，对于玛瑙及其他玉石细致化的划分影响依然在延续。鉴定时应注意到这一点。

红玛瑙标本

南红凉山料圆珠

<div align="center">红玛瑙、和田玉组合手串</div>

5. 民国及当代玛瑙

　　民国玛瑙在数量上常见，但显然没有清代那么多。从产地上看，细致化的划分依然存在，但显然也不及清代南红作品那么多。多是一些普通的玛瑙制作的一些普通的器皿，完全是一种延续传统的态势，创新很少，不再过多赘述。这一点我们在鉴定时应注意分辨。

　　当代玛瑙在数量上十分庞大，大量的印章、碗、盘、碟、洗、瓶、笔架、香炉、笔舔、鼻烟壶、牌、挂件、把件、观音、弥勒、佛像、坠、戒指、镯、簪、项链、手串、山子、多宝串、平安扣、隔珠、隔片、瑞兽、茶几、围棋、象棋、镇纸，等等。这主要得益于当代原料的易得性。当代科技的进步，使玛瑙的开采变得容易，大量的玛瑙被开采出来。玛瑙由过去十分珍贵的材料逐渐变得常见和普通，这是当代玛瑙整体上与古代的区别。同时，当代玛瑙在细致化的特征上迅猛发展，其主要特点是对玛瑙优中选优。当然，选优的标准有很多，如质地、色彩、历史、数量，等等。优劣细致化的过程依然在继续。不过目前市场上主要选优的产品是南红和战国红。下面我们具体来看一下。

（1）普通玛瑙。普通玛瑙的数量在普通大众市场上依然是常见，在大街小巷内小摊位上就经常可以看到普通玛瑙的身影。特别在小商品城内各种各样普通质地的玛瑙，五颜六色，漂亮极了。在件数特征上是堆积如山，手镯、装饰品一个摊位的存货就有几百上千件之多。当然，这些普通的玛瑙并不值钱，通常几块到几十块钱一个，多是使用大型机械化生产的产品。不过这些普通玛瑙当中也有一些，色彩、质地、纹理俱佳者，有的可能也有一些人文历史。在这些玛瑙中或许有些会成为下一个南红和战国红；但这需要我们的判断。这是普通玛瑙在件数特征上的现状。鉴定时注意分辨。

马达加斯加白玛瑙筒珠

南红凉山料圆珠

南红凉山料摆件

（2）南红保山料。南红保山料是传统的南红制品，在清代就已经是极为名贵，是王公贵族手中的玩物。当代这种料子依然受到人们的青睐，是目前高档玛瑙市场上的主流。传统品在件数特征上有见，但不是很多，价格也是比较贵，不是像市场上那样论克卖，而是论件。一个清代的小鼻烟壶上万元，通常南红保山料的古董多是在拍卖会上才能够见到，且大多数已经被藏家收藏了，因此古董料实在是少见。如果有人拿一大批量古代的保山料南红，从件数特征上我们不用看基本就可以判定是假的。这一点我们在鉴定时应注意分辨。

马达加斯加红玛瑙镯（三维复原色彩图）

马达加斯加玛瑙镯（三维复原色彩图）

南红保山杨柳料

南红保山杨柳料

南红保山杨柳料标本

　　南红保山料当代品，是目前市场上的主流，但总体来看也不是很多，在柜台内总是熙熙攘攘地摆上几个。柜台内大多数的南红都是四川料，而且特别优质的并不是很多。这主要是由于南红保山料在清代乾隆时期实际上开采得已经差不多了，即使我们现在的技术先进，在其原产地也已基本绝迹。有一段时间已经挖地三尺了，当然现在政府早就将南红产地保护起来，不能再挖了，再挖连地质都会出问题，所以南红保山料在数量上的确是受到了资源的限制，目前在市场的表现就是"物以稀为贵"，当然这也是当代南红在件数特征上的核心，鉴定时应注意分辨。

南红保山杨柳料碟（三维复原色彩图）

南红保山料碟（三维复原色彩图）

南红凉山料执壶（三维复原色彩图）

（3）南红凉山料。

南红凉山料是 2009 年在
保山南红资源枯竭的情况
下，人们寻找到的主要替
代品。的确南红凉山料在品质上也
是不错，但与保山料相比的确是有一定
的差距，不过这是目前人们所能寻找到的比
较好的红玛瑙了，这种玛瑙在数量上占据了当今玛瑙市场的主流。
我们在商场、古玩城等地都可以看到，如果你问南红玛瑙的产地，
得到的回答大多数是四川凉山。无疑，这种料受到了人们的青睐。
绝大多数人所佩戴的南红玛瑙也是凉山料。因此，从件数特征上看，
南红凉山料已经稳稳地站稳了市场，其价格也是扶摇直上，每年几
乎是以两位数百分比的速度向上增长。但是从件数特征上看，南红
凉山料实际上也是比较复杂，这主要是由其固有的特征所决定的。
因为凉山料南红在价格上因为品级的差别很大。不过从件数特征上
看，优质品级的凉山料南红也是很少见，多数见到的是普通或略优
品级的南红。略有瑕疵的南红也是常见，这一点从价格上其实反应
得更清楚。正所谓"一分价钱一分货"，而这七个字其实也是南红
凉山料在件数特征上最真实的写照。

南红凉山料摆件

南红凉山料摆件

南红凉山料摆件

南红凉山料手链

南红凉山料算珠

南红凉山料圆珠

南红凉山料摆件

战国红玛瑙隔片

战国红摆件

（4）战国红。战国红的料子由于发现时间不长，虽然斑斓的色彩使其名声大噪，但价格却是没有南红高。当然，这个价格因素是非常复杂的：一是受到历史文化的影响；二是受到产地、储量等的影响。但显然战国红以其特有的魅力征服了很多藏家，价格也是扶摇直上，非常具有升值潜力，同时也是市场上销售的主流。我们可以看到，玛瑙市场上基本形成了"南北对峙"的局面：在一个柜台内往往是左边摆的是南红，而右边摆的是战国红。因为南红产于南方，而战国红产于北方，所以有此说法。可见，在件数特征上南红和战国红显然也是巾帼不让须眉。鉴定时应注意分辨。

战国红摆件

战国红筒珠

战国红摆件

战国红摆件

南红凉山料手链

战国红隔片

南红保山杨柳料

战国红隔片

三、完残特征

　　中国古代玛瑙数量相当丰富，完整器有见，残缺者亦有见。由于玛瑙具有硬度大、不易磨损等特点，在完残特征上以完整器为显著特征。从出土位置看，多以墓葬出土为多见。从时代上看，越是早期的玛瑙越是容易受到这样或者是那样的污染，这是因其被开采时间长，所以受到损害的可能性就大。从残损上看，是玛瑙有残当中较为严重的一种，指玛瑙中有一部分缺失。但是这种情况在玛瑙上比较少见，玛瑙上比较常见的有残特征是磨损。当然我们知道玛瑙的硬度比较大，一般情况下是不怕磨损的，通常磨损多是人为的。

战国红摆件

战国红摆件

　　我们来看一则实例，西汉玛瑙印章"M102：32，出土时印文被磨"（扬州博物馆等，2000）。由此可见，这件玛瑙印章上的文字是有意打磨掉的，这种情况的确是不多见，但在玛瑙之上有见。另外，常见到的情况就是穿系玛瑙的绳子腐烂掉了，如串珠、项链等都会散落一地，这样会出现样式不明的情况。我们再来看一则实例，西汉玛瑙印章"原串饰样式不明"（广州市文物考古研究所，2003）。这是玛瑙残缺最主要的一种原因，而且这种现象十分普遍，基本上墓葬中穿系的绳子都是断的。所以我们看到的古代串珠等，基本上都是复原品。另外，对于玛瑙制品而言最为常见的有残器是使用痕迹。这一点很明确，因为玛瑙曾是一种被人们真正使用过的物品，所以对于早期的玛瑙而言，基本上都有使用痕迹。如新石器时代玛瑙尖状器"顶端有疤痕"（成都市文物考古工作队，2002）。再如，商代玛瑙斧"M28：21，孔至顶部有摩擦痕"（安徽省文物考古研究所等，1999）。可见玛瑙的确是在被用的。使用痕迹有可能是摩擦所导致。下面我们具体来看一看。

南红凉山料手链

1. 新石器时代玛瑙

新石器时代玛瑙在完残特征上比较好。来看一件实例，战国玛瑙环"均基本完整"（长沙市文物考古研究所，2003）。玛瑙缺失的情况有见，但不是造型本身的断裂缺失，多数是由于串珠的散乱而造型的式样模糊等。另外是磨制，对于新石器时代玛瑙制品而言，最为常见的有残器是使用痕迹，这一点很明确。因为玛瑙是一种人们真正在使用的物品，使用痕迹是必然的。晚期主要以孔洞为显著特征，在孔洞处常见有磨损的痕迹。这一点我们在鉴定时应注意分辨。

2. 商周秦汉玛瑙

商周秦汉玛瑙完整者多见，很少见到残缺的情况。多数残缺是由于穿系的绳索腐烂之后，串珠散落所导致。但磕碰伤痕有见，多是轻微的磕碰，磨伤、划伤等很少见。总之，该时期玛瑙在品相上保存得还是比较好，当然这主要与玛瑙的质地有关。

3. 六朝隋唐辽金玛瑙

六朝隋唐辽金时期玛瑙完整器有见，在墓葬和遗址当中都有出土，以墓葬出土为多见。串珠等有见散落的情况，有的珠子找不到，有的穿系方法不知道，无法进行复原和恢复原状的工作。真正残断、磕碰、磨伤、崩裂、划伤等的情况比较少见。这一点我们在鉴定时应注意体会。

玛瑙碗（三维复原色彩图）·西周

4. 宋元明清玛瑙

　　宋元明清时期完整的玛瑙数量最多，特别是明清时期的玛瑙器皿。在博物馆中、拍卖行、古玩市场以及众多的私人收藏品中，我们都发现了数量众多的毫无瑕疵的玛瑙。这种情况在其他质地的器皿很少见。残缺的情况有见，但主要是无法复原问题，即穿系的绳子断掉之后玛瑙串珠呈现出散落状，这种情况以墓葬出土为多见。但墓葬出土者多数能够复原，因为这些散落的玛瑙基本都在原位。反而是有些传世的玛瑙串珠类由于时间长了之后穿系绳子腐烂，玛瑙珠子有的很难找到，成为遗憾。从磕碰的情况看，这一时期的玛瑙制品有见，但不是很严重。磨伤和划伤的情况几乎不见，因为玛瑙的质地坚硬，除非用刻刀等，一般的材质无法令其磨伤或划伤。总之，宋元明清的玛瑙在完残程度上表现比较好。这一点我们在鉴定时应注意分辨。

玉组佩·西周

5. 民国及当代玛瑙

民国玛瑙基本上完好无损，损坏的情况很少见，这与其距离现在时间比较近，又是珠宝首饰，比较珍贵有关。总之，民国玛瑙在品相上保持了一个比较好的状态，鉴定时应注意分辨。当代玛瑙基本上都是完好无损者，因为大多数当代的玛瑙制品都是商品。商品的属性是不允许有瑕疵的，而完整是其最基本的表现形式。另外，一部分就是已经被收藏者购买的收藏品。而我们知道，收藏者对于藏品的保护总是精心的。这样，当代玛瑙在品相上可以说是最好的。但当代玛瑙的品类比较多，人们对它的保护等级也不一样，所以下面我们详细来看一下。

（1）普通玛瑙。普通玛瑙在完残特征上自然也是以完好无损为显著特征。但对于普通玛瑙制品而言，由于过于普通，价格不高，所以其保护的级别不是很高。如我们在购买时很少见到对普通玛瑙垫上衬垫的，所以磕碰的情况有见，但是几率很小。总之，在品相上是比较好。鉴定时注意分辨。

（2）南红保山料。南红保山料的玛瑙制品十分珍贵，磕碰的情况很少见。除了传世品之上由于历史原因有可能有磕碰等各种各样的缺陷，但数量基本上也是偶见的状态。当代南红保山料的玛瑙制品，可谓都是精绝之器，价值很高，通常情况下人们对于它都是特别的保护。如在柜台上看时，必然服务人员先拿来衬垫，以防止掉下来磕伤，收藏者在收藏到南红保山料后，对其也是呵护有加，所以无论是古代还是当代，保山料南红在品相上都比较好，这一点我们在鉴定时应注意分辨。

内蒙古阿拉善戈壁玛瑙摆件

南红保山杨柳料标本

南红凉山料算珠

战国红摆件

战国红摆件

（3）南红凉山料。南红凉山料的红玛瑙的确是很珍贵，以完整器皿为主，各种有残的情况很少见，是目前市场上销售南红的主流产品。特别是近些年来在保山南红资源枯竭的情况下，人们寻找到的主要南红的替代品，南红凉山料在品质上也是不错，因此有残的情况很少见。

（4）战国红。战国红的料子由于发现时间不长，主要是当代制作的玛瑙制品，因此以完好无损为显著特征，残缺的情况很少见。但原石除外，一般情况下原石都是打碎后销售，有的是切开一部分。这样做的目的是为了可以看到里面成色。不过，原石并不能算是一种残缺。

南红凉山料手链

四、伴生情况

伴生情况多数是指古代玛瑙，在墓葬出土时和玛瑙一同随葬，也就是一同出土的器物。伴生有远近之分，狭义伴生就是指相邻，这对于判断玛瑙的质地、功能等都有着重要的意义，是鉴定方法的一个重要方面。我们来看一则实例，东汉"此外，还有水晶珠 7 粒、玛瑙珠 2 粒、琥珀珠 28 粒、金珠 3 粒"（广西文物工作队等，1998）。由此可见，古人实际上是将玛瑙、琥珀、水晶摆到同一地位之上，这涉及古人对于玉质的认识问题。古人对于玉质的认识是很深刻的，但对于玉质没有像现代矿物学软玉才是玉的概念，而是将琥珀、玛瑙、水晶等，凡是具有坚韧、润泽、细腻等质地的美石都认为是玉器，包括硬玉（碱性辉石类矿物组成的集合体）都放在了玉器的范畴之内。汉代许慎《说文解字》称玉为"石之美有五德"。所谓五德即指玉的五个特征。凡具温润、坚硬、细腻、绚丽、透明的美石，都被认为是玉，可见其概念之宽泛。之所以与金器放在一起显然是与其共同组合而成器物造型，如珠宝项链类，也就是我们现在的多宝串饰类，是珍贵的材质制作而成的珠子串联在一起组成器物。可见在汉代，玛瑙与琥珀、水晶、金器同等贵重。总之，伴生特征特别复杂，作为鉴定书，本书只取鉴定要点。下面让我们具体来看一下玛瑙各个历史时期在伴生特征上的特点。

红水晶摆件

紫晶标本

和田玉标本

弧线圆点纹彩陶钵

1. 新石器时代玛瑙

新石器时代玛瑙在伴生特征上十分明确。我们来看一则实例，新石器时代"遗物较丰富，以石器为主，另有少量陶片，石器所用原料以石髓玛瑙为主"（闫永福，2001）。伴随着玛瑙出现的是新石器时代的陶器，这似乎有点意外。但我们可以看到，这个实例中的玛瑙是作为石器随葬的，就是普通的石器，而不是珠宝。这样看来，陶器与其伴生也就很容易理解了。不过同时我们也可以看到玛瑙在遥远的新石器时代里最初就是普通的石头，被制作成了各种工具和农具。再来看一则实例，新石器时代玛瑙"细石器原料多用燧石和玛瑙"（滦平县博物馆，1998）。由此可见，这些新石器时代的细石器显然都是用我们当代认为的珠宝制作而成的。显然不是新石器时代的人多奢侈，而是当时根本就是没有珠宝的概念。就是如同路边的石头一样，这一点不仅仅是玛瑙，如水晶、和田玉、黄龙玉等诸多当代被认为是很贵重的材质，实际上在人类文明的童年时代里就是如同普通的石头。这一点我们在鉴定时应逆向思维，要能够理解。因为只有这样，我们才能够理解新石器时代很多用玛瑙制作而成的农具、工具类器物。但是也有很多证据表明"是金子总会发光的"，诸多我们现在认为的珠宝玉石类在新石器时代中晚期就已经被奉为珠宝，玛瑙也是这样。我们随意来看一则实例，新石器时代玛瑙璜"M4：4，高 6.5 厘米"（苏州博物馆等，2000）。由此可见，玛瑙居然可以制作新石器时代祭祀的重要玉礼器造型璜，可见在这一时期玛瑙显然已经被认为是珍贵的材质之一。

2. 商周秦汉玛瑙

商周秦汉时期与玛瑙伴生的器物很常见，让我们来看一则实例："项链由 1 件椭圆形玉饰、11 件玉珠、1 件玛瑙珠、5 件水晶珠、1 件扁平玉管和 2 件绿松石珠组成"（中国社会科学院考古研究所洛阳唐城队，2002）。上例与玛瑙共同组成项链组件的质地分别是玉器、水晶、绿松石，以玉器最为丰富。而我们知道，商周秦汉玛瑙在这一时期都被认为是玉。因此，如果用古人的观点来看，就是这件项链是用不同的玉器构成。既把玛瑙、水晶、绿松石都看作是玉质。古人的这种认识比较固化，我们在鉴定时应多参考。如果发现组合材质很怪异的项链等，要引起重视，先看一下是不是伪器。以上这个实例很有代表性，实际上商周时期玛瑙的伴生器物就是如上，都是一些被认为是玉或者材质贵重的材料，相互组合在一起成器。

组玉佩·西周晚期

组玉佩·西周至春秋之际

银丝标本

　　秦汉时期基本延续了这一特点。我们来看一则实例，西汉"玛瑙、水晶等珠饰，珠饰出于 M3、M4"（广州市文物考古研究所，2003）。此例为传统的延续，说明秦汉时期包括西汉时期与商周时期在玛瑙伴生性上几乎没有太大变化。再来看东汉时期，东汉时期厚葬发展到纵深阶段。我们来看一则实例，东汉"还有金戒指、银戒指、银手镯、骨刀、玉璧、石砚、钱币、水晶珠、玛瑙珠、琥珀珠、琉璃珠等，相当多的器物残损，仅能修复其中大部分"（辽宁省文物考古研究所等，1999）。由此可见，东汉时期玛瑙伴生器物较多，仅上例中看到的材质就有金、银、骨、石、铜、琥珀、琉璃等诸多材质，明显地可以看到在东汉时期玛瑙的伴生器物材质增加了很多。

"开元通宝"铜钱·唐代　　　　　　　　　"开元通宝"铜钱·唐代

3. 六朝隋唐辽金玛瑙

六朝隋唐辽金时期的玛瑙基本上都是作为一种装饰物存在。我们来看一则实例，六朝"墓内共出土各类遗物 151 件，有青瓷器、陶器、铜器、银器、铁器、玛瑙和钱币等"（黑龙江省文物考古研究所，2003）。可见，基本上是延续了东汉时期的特点，玛瑙伴生的器物材质依然很多，几乎重要的材质都凑齐了。但由于六朝时期是限制厚葬的，所以很快这种多材质随葬的情况就绝迹了，与玛瑙共生的器物随之减少。如六朝有一例"其他数量较少，有骨纺轮、铁犁铧、玛瑙管饰各 1 件"（黑龙江省文物考古研究所，2003），可见数量已经少到了极点。骨纺轮、铁犁铧都可以从伴生器物中划去，因为一个是生产工具、一个是农具，可能不是真正与玛瑙伴生的器物，只是放在那里而已。看来在废除厚葬的重压之下，玛瑙在伴生器物上跌落到了谷底。隋唐时期，玛瑙又一次进入了鼎盛时期，我们来看一下这一时期的情况：唐代"共 31 件，种类有铜器、石器、蚌器、牙饰和玛瑙饰品"（黑龙江省文物考古研究所，2003）。可见，唐代在玛瑙的数量上显然是有一个飞跃，数量又重新多了起来。这个实例当中就有铜、石、蚌、牙等与玛瑙相伴，看来时代与经济发展是玛瑙伴生物品多寡的晴雨表。辽金时期，玛瑙在伴生器物的材质上基本模仿唐代。我们来看一则实例，辽代"共 65 件，包括铜、铁、瓷、陶、玛瑙、骨、木和石器等"（中国社会科学院考古研究所内蒙古工作队，2003）。由此可见，依然是多种材质相伴，基本上是延续唐代特征。

4. 宋元明清玛瑙

宋元明清时期的玛瑙在伴生特征上依然还是延续前代，并没有太多的创新。在这一时期，玛瑙的珠宝属性已固化，不再过多赘述。

小口孔雀绿釉梅瓶·宋代

5. 民国及当代玛瑙

民国及当代玛瑙基本上不存在墓葬伴生情况，但存在着与其质地接近的器皿共同出现在市场上的情况。特别是对于玛瑙本身而言更是这样。因为玛瑙目前在市场上主要销售的是南红和战国红，不同产地之间存在着相互伴生销售的情况，而这种销售有的时候很难区分。如保山南红和凉山南红之间，大的方面很好区分，但有时真正也是难以区分。我们曾经做过一个实验，将南红保山料和凉山料数百块原石混在一起，请采集者去分辨，大多数可以挑选出来，但有一块保山料原石，到最终也没有能够挑选出来。由此可见，是相当难以挑选的。这一点我们在鉴定时应有充分的认识。还有就是销售时，当代玛瑙伴生老玛瑙的问题，这其实是一种作伪了。但是有的时候也不容易判定，因为料子都是一样的。我们只有根据时代特征来进行判定。还有就是非南红和非战国红的玛瑙，有的很相似，只有微小的区别，用来伴生也就是仿南红和战国红，一个柜台内就放在一起，你自己挑吧。所以说，如果不是很专业的人，在购买玛瑙时一定要谨慎。不然就只能碰运气。这一点我们在鉴定时需要分辨。

红玛瑙摆件

红玛瑙摆件

南红凉山料摆件

南红云南保山杨柳料

南红云南保山杨柳料

玛瑙镯（三维复原色彩图）·西周

第二节　工艺鉴定

一、穿　孔

　　玛瑙作为一种装饰品存在，特别是作为挂件、把件、串珠类等，穿孔以利穿系是必不可少的。穿孔磨损程度是玛瑙饰品是否实用的重要标志，同时也是对古代玛瑙洞穿真伪的关键。同时穿孔大小、钻孔方法、造型、位置等也都是鉴定的重要依据。我们随意来看一则实例，汉代玛瑙饰"穿孔直径 0.5 厘米"（白城市博物馆郭珉，1997）。由此可见，穿孔对于玛瑙制品而言具有特殊意义。下面让我们具体来看一下玛瑙在各个历史时期的穿孔特征。

红玛瑙、和田玉组合手串

南红凉山料圆珠

马达加斯加白玛瑙筒珠

1. 新石器时代玛瑙

新石器时代玛瑙在穿孔上特征比较明显，下面我们来看一则实例：新石器时代玛瑙璜"M4 ：4，两端各钻有一对象鼻孔"（上海博物馆考古研究部，2002）。这是新石器时代著名的良渚文化墓葬当中发掘的一件玛瑙制品，钻孔的位置是在两端，钻孔十分讲究艺术性，为象鼻的形状。由此可见，新石器时代在钻孔技术上十分发达，不仅能在质地坚硬的玛瑙之上钻孔，而且还能够随意钻出各种形状的孔部特征。这一点即使比起我们现在的玛瑙制品也毫不逊色。可见新石器时代并不像我们想象的那样落后。这样，我们也可以看到对于玛瑙制品而言，一开始，人们就十分重视钻孔，钻孔在时代上起点较高。这一点我们在鉴定时应注意。

2. 商周秦汉玛瑙

商周秦汉玛瑙在穿孔特征上基本延续传统，在技术上已经相当成熟，在态度上十分认真。而这一特征从商代便开始了，我们来看一则实例，商代玛瑙璜"87M15：44，两端各有2个孔眼"（安徽省文物考古研究所等，1999）。由此可见，在钻孔上商代比新石器时代更为复杂化，这件器物便是钻了4个孔，显然有复杂化。这件器物的设计，如果仅仅是为了穿系，两端各钻一个孔就可以了。从造型上看，含山县凌家滩遗址第三次发掘还报告了一件商代玛瑙环"T1004③：1，表面对钻两个对称的圆孔"，可见在当时圆孔十分流行。而且这一趋势一直流传了下来，直至明清，乃至我们当代在孔部造型上都是以圆孔为显著特征。但从新石器时代诸多象鼻孔的造型来看，实际上圆孔的造型与新石器时代相比是一种简化。这一点我们在鉴定时应注意理解。另外，从钻孔的方式上看，主要是两面对钻，这一点不仅凌家滩遗址是这样，许多商代遗址也都是这样。从大小上看，也是大小不一，如玛瑙钺的孔部就比较大，而玛瑙串珠上孔部就比较小，主要是依据造型而定。实际上，在商周秦汉时期，各种大小的孔部造型都有见。西周时期玛瑙在造型上的特征基本延续商代，但与商代相比较而言，在穿孔特征上有进一步的简化。我们来看一则实例，西周玛瑙璜"M119：26，两端各钻一孔"（中国社会科学院考古研究所等，2000）。由此我们可以勾画出一条简化的曲线，仅以上面的例子来看，商代是简化了新石器时代的象鼻孔，而西周是进一步简化了商代的玛瑙璜两边各钻双孔的造型，改为两端仅各钻1孔，这样做更为实用。

春秋战国时期玛瑙在穿孔特征上基本延续西周传统。只是在某些方面有些革新。我们来看一则实例，春秋战国玛瑙坠饰"M3：23，中间穿孔"（青州市博物馆等，2002）。中间穿孔讲究的是对称，这一穿系方式实际上也是传统延续下来的方法，体现出的是平衡。虽然在新石器时代就有见，但春秋战国时期无疑将其固定化了，对于后世的影响非常之大。这一点我们在鉴定时应注意分辨。在春秋战国时期像这样的例子很多，我们再来看一则实例：春秋玛瑙项链"M3：28，中有穿孔"（山东大学考古系，1998）。由此可见，中间穿孔在春秋战国时期的盛行。

西汉时期基本延续了前代的特征，特别是中有穿孔的特征，如西汉玛瑙珠"T1③：110，中有圆孔"（中国社会科学院考古研究所，2002）。由此可见，中部穿孔的观念已经深入人心。但西汉时期在穿孔上不仅仅是延续传统，也有很多常见的特点，如在巧妙穿孔方面有所发展，我们来看一件西汉玛瑙印章"M102：32，虎腹下有一穿孔"（扬州博物馆等，2000）。这种在虎腹位置下的一个穿孔，给人以巧妙构思之感。由此在穿孔构思多样化方面前进了一大步。东汉时期玛瑙制品在穿系上特征比较明显，一是继续延续传统，二是有自己的一些习惯性特点。下面我们以东汉玛瑙耳铛为例来看一下。先来看一则实例，"M6a：87，中心有纵穿孔"（广西壮族自治区文物工作队等，2003）。由此可见，这件耳铛的穿孔与众不同，它也十分讲究对称，只是与传统的穿孔方向调整了一下，是纵向贯穿的，体现了东汉时期高超的钻孔技术。可以想象，钻孔的难度之大，这是手工进行的钻孔，而且是在摩氏硬度7左右的玛瑙之上，同时也反映出了东汉时期在钻孔技术上的随意性。再来看一则实例，东汉玛瑙珰"一头穿孔"（广西壮族自治区文物工作队，2002）。可见这件玛瑙珰在钻孔上的随意性，随意在一头钻孔就可以了。总之，秦汉玛瑙穿孔技术已相当成熟，显示了这一时期高超的琢磨工艺。

玉项饰·春秋早期

七璜组玉佩下半部（局部）·西周

3.六朝隋唐辽金玛瑙

六朝隋唐辽金玛瑙穿孔技术相当发达，在延续传统的同时也有创新。我们来看一则实例，六朝玛瑙珠"M1∶17，中部有一圆形穿孔"（老河口市博物馆，1998）。中部穿孔为传统部位，圆形孔前代也有，由此可见，这件玛瑙在穿孔上完全是传统的延续。由于六朝时期官府限制厚葬，随葬的玛瑙制品不是很多，过多的例子就不再赘述。但总的来看，六朝时期主要是延续传统，创新不是很常见。真正创新多数是在唐代，但唐代显然也是在延续传统的基础之上的创新。如唐代玛瑙珠"中有穿孔"（黑龙江省文物考古研究所，2003），这样的穿孔完全是延续传统。但是我们再来看一则实例，唐代玛瑙珠"穿细孔"（中国社会科学院考古研究所四川工作队，1998）。这件玛瑙珠穿孔特别细，这其实也是一种创新，因为给人们的是一种异样的感觉。有的时候，我们不仔细观察甚至觉得只是一个球体，并没有穿孔一样。五代基本延续唐代，我们来看一则实例：玛瑙串饰"均有穿孔"（西藏自治区山南地区文物局，2001）。该器物的造型是串饰，每一个串饰的组件都应该有穿孔，这一点很明确。通常情况下这一时期玛瑙在穿孔特征上精益求精，钻孔并不影响其美观，可以说是实用与装饰之美结合的典范。辽金时期玛瑙制品在穿孔特征上基本延续前代，不再赘述。鉴定时应注意。

4.宋元明清玛瑙

宋元明清玛瑙在穿孔特征上继续延续传统。但是这一时期穿孔的情况显然是在逐渐退化，程式化的特征成为其主要的特点。我们来看一则实例，明代玛瑙饰件"M1∶11，中间有穿孔"（南京市博物馆，1999）。这显然是传统的延续，但是这种传统在这一时期基本上被固化了，大量存在的是中间穿孔的造型，出奇、创新等的造型基本不见了，而且大量存在一端穿孔的情况。如吊坠多是在一端穿孔，讲究对称。当然也有少量的器皿在穿孔上是极度创新，但这改变不了大趋势。

南红凉山料圆珠

马达加斯加白玛瑙平安扣

5. 民国及当代玛瑙

民国玛瑙在钻孔和穿孔上特征基本延续清代，穿孔程式化的趋势依然明显，基本上没有太大的创新。当代玛瑙在穿孔上特征比较明确，就是圆度规整，整齐划一，非常标准。人们对于穿孔是既熟悉，又陌生。当代玛瑙似乎不太重视玛瑙的打孔。总之是机器打孔之后，总的特点是相似性过于强。下面我们具体来看一下。

（1）普通玛瑙。普通玛瑙数量庞大，在打孔上主要是依据造型而行，没有过于明显的特征。通常都采用机器打孔，规格相同，整齐划一，优点是圆度规整，造型一致。鉴定时注意分辨。

（2）南红保山料。南红保山料有一部分是清代的作品，在穿孔特征上是手工进行。与当代机器穿孔不同之处在于，老南红穿孔有手工制作的痕迹，并不是那样整齐划一。器物造型之上的孔略有不同。而新南红则没有工匠制作的痕迹，无论多复杂的穿孔，钻头型号相同，尺寸就完全相同，形制相同。而且一般情况下会有一些使用痕迹，但使用痕迹不会太明显。因为玛瑙本身质地比较硬，鉴定时应注意分辨。

战国红筒珠

战国红隔片

（3）南红凉山料。南红凉山料大多数为当代开采制作而成的玛瑙器皿，在穿孔特征上基本以机器穿孔为显著特征。因为玛瑙太硬了，当代几乎没有人用手工再进行穿孔了，这是其基本的特征。但在穿孔的部位及大小上，基本还是延续着传统。

（4）战国红。战国红同南红凉山料一样基本都是当代的制品，过去的也有，但数量很少，有穿孔者数量就更少了。在穿孔上基本延续传统，只是由过去的手工改为机器穿孔。形制也是钻头型号相同，大小、造型就相同，以程式化为显著特征。

马达加斯加红玛瑙算珠　　　南红凉山料圆珠　　　　　　　　　南红凉山料圆珠

红玛瑙摆件

马达加斯加红玛瑙圆珠

二、打　磨

　　打磨是玛瑙做工的重要的环节。玛瑙的打磨在古代工艺比较复杂，因为玛瑙的硬度比较大，难以打磨，而古代又没有现代化机械。但玛瑙不打磨不成器，这一点特别明显。经过打磨抛光的玛瑙光泽四溢，非常漂亮，而未经过打磨玛瑙就如同石头一般，甚至比石头还难看。因此，无论是古代还是当代，制作玛瑙饰品都将打磨放在重要位置。从整体来看，玛瑙在打磨上是精益求精，粗制者少之又少。下面我们具体来看一下。

红玛瑙秋叶

1. 新石器时代玛瑙

新石器时代玛瑙在打磨上特征异常的明显，就是精工细琢磨，打磨非常仔细。我们来看一则实例，新石器时代玛瑙璜"M4：4，周边磨圆"（上海博物馆考古研究部，2002）。由此可见，这件玛瑙璜在打磨上是非常仔细，显然是付出了相当大的努力。因为靠新石器时代的技术打磨硬度极大的玛瑙实在是太难了，从这件玛瑙璜只是周边打磨也可以看出这一点。但是在新石器时代，人们还是拿出了极大的热情来打磨这件玛瑙璜。而且在新石器时代人们对于玛瑙制品的打磨几乎是普遍的，特别是对于礼器的造型更是如此。我们再来看一则实例，新石器时代玛瑙玦"AT01②：7，磨制精细"（广西壮族自治区文物工作队等，2003）。由此可见，新石器时代玛瑙在打磨上的特征是非常明确的，就是态度非常认真，多数玛瑙制品被打磨得非常光洁。同时也显示了新石器时代极高的打磨技术。

2. 商周秦汉玛瑙

商周秦汉玛瑙在打磨上依然延续传统，在态度上相当认真，打磨精益求精。来看一则实例，很多器皿打磨都是全方位的，商代玛瑙环"T1004③：1，表面抛光"（安徽省文物考古研究所等，1999）。由此可见，这一时期的玛瑙制品在打磨上相当仔细，基本

玛瑙珠玉组佩·西周

上不留死角。在打磨方法上，商周时期应该手工和机械相互结合。早期砣轮多是青铜砣轮，因为只有这样才能将这件商代玛瑙环表面抛光。实际上，抛光也是一种打磨，一种更加精细化的打磨。而且我们知道，环的造型实际上是比较难打磨和抛光的，因为稍微用力，环就会断掉。由此可见，商代在玛瑙打磨技术上的高超技艺。当然，玛瑙器皿被抛光的情况在商代很常见。如在凌家滩遗址第三次发掘当中，不仅出土有环，而且还有璜、斧、钺等都是表面抛光，可见其应用之普遍。西周时期玛瑙制品在打磨上基本延续商代，只是更为仔细了。我们来看一则实例，西周玛瑙璜"M119：26，通体磨制精细"（中国社会科学院考古研究所山东工作队，2000）。由此可见，西周玛瑙璜在打磨上是精益求精，几无缺陷。这一点从虢国墓当中看基本上也是这样，大量的玛瑙珠类被打磨得圆度规整，造型隽永。秦汉时代也是这样，基本延续了商周时期玛瑙在打磨上的特征和认真态度。而汉代应该使用的是锻铁砣轮。砣轮的使用使得复杂器物的制作成为可能，是玉器的生产和石器的生产分离的标志，同样对于的玛瑙的制作也是这样。总之，商周秦汉玛瑙在打磨上表现出的是非常出色。

3. 六朝隋唐辽金玛瑙

六朝隋唐辽金玛瑙在打磨和抛光上也是非常漂亮，打磨全方位，即使再复杂的器皿，都被打磨得润泽、光滑。我们来看一则实例，六朝玛瑙管"F2：38，磨制"（黑龙江省文物考古研究所，2003）。由此可见，这件玛瑙管是通体磨制。不要看造型小，但手工制作非常麻烦。这一时期通常情况下使用铁质砣轮进行简单机械打磨。显然，我们也可以体会到，生产这件玛瑙管的艰难程度。隋唐时期在玛瑙制作上打磨也是一道很重要的工序。唐代基本延续传统，我们来看一则实例，唐代玛瑙珠"表面略微磨光"（中国社会科学院考古研究所四川工作队，1998）。由此可见，这件玛瑙珠子是被整体磨光的，不仅打磨而且进行抛光，显然是象征器物精致化的方向发展。辽金时期基本上延续了唐代的特征。来看一则实例，辽代玛瑙圆柱形管"表面抛光"（中国社会科学院考古研究所内蒙古工作队，2003），可见这件玛瑙圆柱形管在打磨上也是费了一番工夫，打磨极为精细。

南红凉山料圆珠

4. 宋元明清玛瑙

宋元明清玛瑙在打磨上基本是延续传统，打磨得十分精细，可以说是精益求精，基本上看不到明显的缺陷，彰显了其高超的打磨技艺，鉴定时应注意分辨。

5. 民国及当代玛瑙

民国玛瑙在打磨上依然延续前代，打磨仔细是其显著特征，通体打磨，总之很少在打磨上出问题。这一点我们在鉴定时应注意分辨。

当代玛瑙制品对于打磨相当重视，打磨仔细、极为重视细节，不放过任何死角，通体打磨干净，无论大小件玉器，这是目前我们从市场上看到的现状。当然这与当代玛瑙的打磨主要由过去的手工制作转向机械化有关。当代的玛瑙想要打磨实际上是比较容易的事情，特别是对于一些珠子等更是这样。但是当代玛瑙与过去存在一个在打磨上不相同的问题，这就是态度问题。古代玛瑙在打磨上态度都是一样的，而当代玛瑙在打磨和抛光上虽然有了机械，但态度却大不一样，主要以玛瑙的等级为区分。如珍贵的南红在打磨上自然没得说，而普通玛瑙则是在打磨上认真态度不如南红。有些复杂的造型，当机械作业不到的地方，也就没有打磨。下面我们具体来看一下。

马达加斯加白玛瑙筒珠

马达加斯加白玛瑙平安扣

（1）普通玛瑙。普通玛瑙数量庞大，在打磨上主要是依靠机械打磨，如一些珠子等打磨没有问题，多数被打磨得圆度规整、整齐划一。但是一些稍微复杂的造型，在打磨机械作业不到的地方往往就有问题。总之，是不用手工再进行修正，机器打磨是什么样就是什么样，特别是在抛光上看起来没有南红仔细。普通玛瑙之所以出现这些情况，主要与当代玛瑙的制作成本有关。你想，几十块钱的东西，在做工上自然不会太好，这其实是本质的原因。鉴定时应注意分辨。

马达加斯加红玛瑙圆珠

马达加斯加红玛瑙平安扣

南红保山料执壶（三维复原色彩图）　　　　　　南红凉山料手链

　　（2）南红保山料。南红保山料在打磨上精益求精，古代的老货自然不必说，是相当的精细，抛光也很好，除了表面变得比当时更加柔和外，其他与当时没有过多的变化。当代南红保山料产品更是这样。由于原料的极度匮乏，所以人们对于保山料已经是非常重视了，大多数是请工艺美术大师来制作，有的还专门请苏州工匠。因为在当代有一种说法，坊间也广为流传，说苏州工匠比较细腻。当然这其中固然有历史传统的因素在里面，不可否认苏州出了很多工艺极为高超的大师，但是其他地方也有很多工艺美术大师在水平上也是极高，所以我们不能一概而论。总之，当代南红保山料在制作时由于人们比较重视，所以在打磨上大多是精益求精，抛光较好，机器打磨不到的地方手工辅助，鉴定时应注意分辨。

　　（3）南红凉山料。南红凉山料在当代也是非常贵重的材质，所以人们对其也是比较重视，一般打磨都是比较认真。但是由于凉山料相比保山料还是比较多，再者在优劣程度上区分也比较大，在这种情况下大多数在打磨上表现还都可以，只有少数质地不太好的，在打磨上偶见态度问题，但基本上也都能看得过去。这一点我们在鉴定时应注意分辨。

　　（4）战国红。战国红的打磨也是十分仔细，这与战国红的质地有关。战国红在色彩上是多色的，打磨以后这些色彩互相映衬，对比强烈，争奇斗艳，绚丽多姿。因此，通常战国红无论优质与否，在打磨上通常都是比较好。

南红凉山料算珠

南红凉山料算珠

战国红玛瑙筒珠

红玛瑙、和田玉组合手串

三、镶 嵌

玛瑙镶嵌时常有见，是制作玛瑙的重要工艺，但显然没有琥珀、钻石等那样普遍。早期镶嵌玛瑙制品就有见，到了明清时期，玛瑙镶嵌工艺变得越来越重，直至当代都是这样。下面我们具体来看一看。

1. 商周秦汉玛瑙

商周玛瑙由于发现得比较少，镶嵌工艺理论上应该是有见的（因为至迟在夏商之际就有见镶嵌饰品，如镶嵌绿松石等），但具体的玛瑙镶嵌实例目前还没有发现。至迟在汉代已经有较为成熟的玛瑙镶嵌制品，我们来看一则实例，西汉饰玛瑙瑟弦枘"顶嵌红玛瑙"（湖南省文物考古研究所等，2001）。由此可见，这件器物的顶部镶嵌有红玛瑙，以加点缀。可见，在西汉时期已经有镶嵌玛瑙出现。当然，这并不是孤例，而是有很多这样的例子。我们再来看一件镶嵌的器物，汉代长方形扣饰"M47：153，中央镶嵌五片玛瑙"（云南省文物考古研究所、玉溪市文物管理所等，2001）。可见，这件扣饰之上的镶嵌应该是比较复杂。这样可以知道，玛瑙在汉代应该是如同我们当代宝石一样的珍贵。

2. 六朝隋唐辽金玛瑙

六朝隋唐辽金玛瑙在镶嵌工艺上基本延续汉代，但发现的数量很少，在随机抽取的实例当中甚至经常不见。由此可知，魏晋南北朝时期反对厚葬的浪潮的确对于玛瑙镶嵌是一个不小的打击。在隋唐辽金时期发现比较少的原因显然也很明确，因为在那个时候，玛瑙数量比较多，与汉代相比已经变得不是那么珍贵了，所以真正出土的镶嵌品也是比较少见。这一点我们在鉴定时应注意分辨。

3. 宋元明清玛瑙

宋元明清玛瑙在镶嵌上特点很明确，宋元时期延续前代，不是很多见；明清时期有见。我们来看一则实例，明代玛瑙花叶形金簪"以玛瑙雕成佛手形镶嵌于簪顶"（南京市博物馆，1999）。由此可见，明代玛瑙花叶形金簪在造型上十分有创意，是一件巧夺天工的作品。实际上清代传世下来的玛瑙镶嵌作品在数量上有一定的量。

4. 民国及当代玛瑙

民国玛瑙镶嵌作品和清代基本相似，为传统的延续，创新比较少见。当代玛瑙制品镶嵌使用的十分频繁，如戒指、项链、胸针等都有见，与金、银、钻、水晶、珠宝等材质相互组合在一起的情况都有。从形状上看，玛瑙被做成橄榄形、椭圆形、各种花形等的造型镶嵌，非常简洁，讲究对称。镶嵌玛瑙的首饰充满着珠光宝气，体现了在镶嵌技术上的高超技艺水平。当代玛瑙镶嵌是狭义的，并不是所有的玛瑙都有见镶嵌制品，而是限制在贵重的玛瑙之上。如保山南红、凉山南红等的优质料。下面我们具体来看一下。

（1）普通玛瑙。普通玛瑙数量庞大，但用来作为镶嵌材质的很少见，特别是在高档一些的珠宝店内几乎不见，地摊上可能会有，但多数是作为装饰品在使用，而并不是真正意义上的珠宝，多是在小商品批发的地方会有一些。我们在鉴定时可以将这些非主流的产品忽略掉。

红玛瑙、和田玉白玉福瓜

红玛瑙、和田玉组合手串

红玛瑙、和田玉组合手串

　　（2）南红保山料。南红保山料中有一部分是清代的作品，镶嵌的情况有见，但并不是很多。而主要镶嵌盛行的还是在当代。当代南红保山料已经是一种十分珍贵的材质了，以克论价。人们将犹如珠宝的南红中最为精致的部分切下，镶嵌在戒指、手链、项链、吊坠、挂件、耳钉等诸多的器物之上，这是主流。鉴定时应注意分辨。

　　（3）南红凉山料。南红凉山料虽然以当代为主，但是凉山料制作的镶嵌作品还是比较多的。镶嵌的形式和大小基本同保山料相似，以吊坠和挂件为多见，创意很多。鉴定时应注意分辨。

　　（4）战国红。战国红制作成为镶嵌作品的情况有见，但明显不及南红，这显然与其新产生，还需要人们进一步认可有关。再者就是文化少一些，这也是战国红，即所谓的"北红"在镶嵌作品上比较少的原因。鉴定时应注意分辨。

红玛瑙、和田玉白玉福瓜

红玛瑙碟（三维复原色彩图）

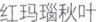

四、纹 饰

玛瑙在纹饰上特征不是很明显。有很多是光素无纹；但也有很多是纹饰十分繁复，具体我们来看一下。从题材上看，玛瑙常见的纹饰主要有兽面纹、雷纹、卷云纹、弥勒、观音、各种弦纹、人物、龙纹、舞狮、渔翁、婴戏、诗文、山石、波浪、海水江牙、花草纹、莲瓣纹、仰莲、枝莲、宝相花、柿蒂纹、牡丹、忍冬、蔷薇、梅花、兰花、叶脉纹、竹、果蔬、瑞兽、鱼纹、牛纹、虎、豹、兔、鹿、驼、狮、蝙蝠、鸭、鹅、鸳鸯、燕、喜鹊、鹤、蛙、蜻蜓、蝴蝶、蝉、生肖、侍女、八仙、历史故事、神话故事、佛教题材、道教题材图案等。总的来看，古代玛瑙并不是以纹饰为重，玛瑙纹饰题材的繁荣主要在于晚期，如明清时期等。特别是当代玛瑙在纹饰题材上发展很快，浮雕和浅浮雕者较为多见。而我们知道，这显然与当代玛瑙的机雕有关，用机器雕刻纹饰，只要在电脑上设计好，轻按鼠标就可以进行了。这样，大量雕刻繁复的作品出现了，同样也催生了相当多的纹饰题材。但如果我们仔细分析这些纹饰，会发现这些纹饰基本上是传统延续下来的纹饰，与琥珀、蜜蜡、玉石等诸多材质工艺品上的纹饰都十分相像。其实这种相互借鉴的情况很正常，我们在鉴定时应能理解。下面我们具体来看一下。

红玛瑙秋叶

红玛瑙秋叶

1. 新石器时代玛瑙

新石器时代的玛瑙，如果按照玉器之上都有繁复的纹饰这一点来看，有纹饰也很正常。但从发现的器皿来看，新石器时代玛瑙之上有纹饰的情况不多见。看来，在新石器时代，玛瑙显然不是以纹饰取胜，而主要是以造型和色彩取胜。这一点我们在鉴定时应注意分辨。

2. 商周秦汉玛瑙

商周秦汉玛瑙在纹饰种类上特征比较明显。商周时期的玛瑙之上刻画纹饰的情况并不多见，如河南三门峡虢国墓地出土的众多玛瑙器皿中，也很少见到的玛瑙刻画纹饰的情况。看来，基本上是延续新石器时代的特点，为传统的延续。

组玉佩·西周

玛瑙上刻画纹饰，在汉代已经是十分流行，这一点是可以肯定的。我们来看一则实例，汉代玛瑙长方形扣饰"M47 ： 153，周围铸雷纹一道"（云南省文物考古研究所等，2001）。可见，这件器物之上刻画了当时较为流行的纹饰雷纹，但是比较简单，只有一道。而我们知道，雷纹多是在商周时期的青铜器之上比较常见。云雷纹显然是一种神秘的礼器性纹饰，因为在它上面突起的圆涡纹、兽头，以及肩下饰夔龙纹都是极为神秘的礼器性纹饰。而到了西周时期仍然是这样，"西周时期的青铜器，有时用雷纹为地，这实际上是延续了青铜器礼器化的进程。可以想象，以雷纹为地的青铜器上存在的各种纹饰多是天上的神灵，或是能上天入地的神物。因为，它可以在云雷纹之上生活。但西周时期的青铜器上的云雷纹没有商代普遍，这从另一方面也说明了在西周时期人们崇拜的对象逐渐从天上回到了人间。但我们应明白，商代和西周时期虽然在纹饰的种类上不同，但这些纹饰的本质和功能没有变，仍然是为了增强青铜器的神秘性，加强其礼器的地位"（姚江波，2004）。

到了汉代，我们知道，礼制惯性的力量已经很弱，雷纹不再是神灵，已经成为了一种纹饰装饰。在汉代的青铜镜上雷纹也是大量有见。这样看来，在玛瑙器皿上出现也很正常。不过从构图上我们可以看到这一时期雷纹被简化到了极点。总之，这一时期在纹饰题材上主要是借鉴商周青铜器、玉器之上的纹饰，如云纹、弦纹、蓝纹、羽毛纹、绳纹、乳丁纹、网格纹、锯齿纹、蕉叶纹、联珠纹、兽纹等应该都比较常见。但商周秦汉玛瑙发现的数量太少，所以真正这一时期玛瑙具体的纹饰特征还很难判断。下面我们来看一则实例，汉代玛瑙长方形扣饰"M47 ： 153，边沿作卷云纹形"（云南省文物考古研究所等，2001）。由此可见，也是比较简单，仅仅是在扣的边沿刻画卷云纹，简洁明了。雕刻技法十分娴熟，也十分精细，线条韵律自然流畅，刚劲挺拔。

3.六朝隋唐辽金玛瑙

六朝隋唐辽金玛瑙在纹饰种类上主要是延续传统，线条流畅，雕刻凝练，图案讲究对称，构图合理，一般以简洁为主，看来并不是以纹饰取胜，不再过多赘述。

4. 宋元明清玛瑙

　　宋元明清玛瑙在纹饰上逐渐丰富起来，在玛瑙制品上雕刻纹饰成为一种风尚。从出土器物来看，主要以明清时期为主，如人物、花卉、动物、兽面纹等都常见。但纹饰雕刻也都是比较简洁，这一点显然是延续传统。如清代比较流行的鼻烟壶之上的浅浮雕人物图，常常就是一个人和一些博古线条纹，与琥珀雕刻形成鲜明的对比，思考其原因，显然是玛瑙硬度比琥珀要大得多，非常难以雕琢。而清代是手工雕刻，所以通常情况下玛瑙纹饰都比较简单。但这种简洁似乎形成了一种风格，如兽面纹也是这样。兽面纹常常以刻画的形式出现在香炉等器皿之上，一般盖炉都会有纹饰。本身兽面纹是一种十分繁复的纹饰，但是雕琢在玛瑙炉之上，由于线条之间的距离比较开阔，所以显得十分稀疏。这显然也是由于极难雕刻所造成的，久而久之形成了一种风格。我们在鉴定清代玛瑙时应注意这样的纹饰风格。总之，明清玛瑙在纹饰上与前代相比显然是比较好的，形成了造型、工艺、纹饰并重的玛瑙制作工艺。

红玛瑙卧狮·清

红玛瑙秋叶

5. 民国及当代玛瑙

民国玛瑙在纹饰上特征与清代很相似，纹饰稀疏，且并不是很常见，创新也有限，或者可以说是基本没有创新。当代玛瑙真正在纹饰上实现了繁荣，各种各样的题材都产生了。产生了一些大型的全景式的立体雕件，较为大型的如山子等，层峦叠嶂，亭台隐于山林之间，构图合理，对比强烈。传统的绘画艺术与立体的玛瑙雕件在一起，全景式的立体雕件有着平、深、高等多层次的艺术效果，且比例尺寸掌握得十分恰当，多为精美绝伦之器，这在以往是不可想象的。当代玛瑙在延续前代的基础上，在题材上集大成，兽面纹、雷纹、卷云纹、弥勒、观音、各种弦纹、花卉纹、人物、龙纹、舞狮、渔翁、婴戏、诗文、山石、波浪、海水江牙、花草、莲瓣纹、仰莲、枝莲、宝相花、柿蒂纹、牡丹、忍冬、蔷薇、梅花、兰花、叶脉纹、竹、果蔬、瑞兽、鱼纹、牛纹、虎、豹、兔、鹿、驼、狮、蝙蝠、鸭、鹅、鸟纹、鸳鸯、燕、喜鹊、鹤、蛙、蜻蜓、蝴蝶、蝉、生肖、侍女、八仙、历史故事、神话故事、佛教题材、道教题材图案等都有见，而且出现的频率是各个时代最高的。由此可见，所谓玛瑙的纹饰题材绝大部分是当代作品的纹饰题材，这一点我们在鉴定时应注意分辨。

红玛瑙、和田玉组合手串

　　从数量上看，观音、弥勒、佛像、佛头、花卉、龙纹等最为常见，出现的频率也最高。从构图上看，构图合理，讲究对称，繁缛与简洁并举。线条流畅，自然、刚劲、有力，多数雕琢精细，具有极高的艺术水平。从雕刻方法上看，当代玛瑙纹饰在雕琢上主要以机雕为主，手工雕刻为辅。优点是大量的玛瑙制品有纹饰，而且现在都是电脑操控，轻按键盘系统自动就可以对牌饰之类的器物进行雕刻，纹饰几无缺陷，和电脑上的模板是一样的，避免了因手工雕刻所带来的不确定性。但缺点是机雕作品千篇一律，纹饰图案都一样，工匠精工雕琢的创造性省略了。当前市场上大量的是这一类作品，优点是价格便宜，还漂亮，也博得了很多人的青睐。少数一些高级的产品，常常是人工雕刻，价格相当高，多为工艺美术大师作品。我们知道，当代在玛瑙雕刻上商业气息比较浓重，并不是所有的玛瑙都是精雕细琢。在商业社会讲究成本与产出，因此当代雕刻精美纹饰者多数是选料精良。下面我们具体来看一下。

　　（1）普通玛瑙。普通玛瑙数量庞大，真正在普通玛瑙之上雕琢精美纹饰者少见，有见雕刻纹饰的情况，但多是纯机器雕刻，千篇一律，规格相同，整齐划一，并没有太高的收藏价值。

　　（2）南红保山料。南红保山料在纹饰上老料作品非常精致，多数是手工雕琢，纹饰以疏朗为显著特征，这些作品在当代也有见，但多数是在拍卖行见到，一般市场上见到的情况很少。当代新制作的南红，在纹饰上则是繁缛与简洁并存，纹饰题材多样化，非常的漂亮，艺术性比较强。以机器雕刻为主，手工雕刻者亦有见，多数是大师作品，具有很高的收藏价值。鉴定时应注意分辨。

南红凉山料摆件

（3）南红凉山料。

南红凉山料当代作品在纹饰
上基本延续传统。纹饰题材与保山
料十分相似，风格、雕刻方法也是基本相同，
只是机雕的比例更大一些。这主要是受到成本的限制，因为南红凉
山料即使纹饰雕琢得再好，也卖不出同等级别的保山料的价格，所
以有的时候请大师来进行手工雕刻就需要考虑很久。但是，随着凉
山料的价值不断扶摇直上，越来越多的好料子是手工雕刻的，变得
越来越有收藏价值了。

（4）战国红。战国红在纹饰题材上比南红少，而且多数以浅浮
雕为主。这是由战国红的多色渐变固有特征所决定的。因为在这样
复杂的色彩上刻画纹饰，其实根本就没有太大的意义。所以，一般
情况下都是浮雕。多数以机雕为主，手工雕的情况偶见。在装饰纹
饰题材、构图等方面主要是借鉴南红等，鉴定时应注意分辨。

南红凉山料圆珠

马达加斯加玛瑙平安扣

南红凉山料手链

五、造 型

　　玛瑙常见的造型主要有手串、摆件、瓶、钺、把件、佩、刮削器、笔架、斧、香炉、尖状器、印章、戈、项链、镞、胸针、石叶、印章、玦、笔舔、石片、扳指、石核、磬、环、杯、凿、牌、童子、璜、水盂、镯、炉、锛、管、杵、人、龙、挂件、鹰、璧、珠、观音、弥勒、鼻烟壶、洗、马、羊、手带、坠、戒指、耳环、平安扣、隔片、隔珠、朝珠、佛像、多宝串、佛珠、念珠、纺轮、簪、璦、珌、耳铛等，由此可见，玛瑙制品的造型种类十分丰富，造型可以说对玛瑙鉴定起着决定性的作用。

水草花玛瑙筒珠

水草花玛瑙筒珠

　　玛瑙在我国的使用历史十分悠久，但早期主要是工具和农具之类。来看一则实例，新石器时代玛瑙片"分刮削器和尖状器两类"（成都市文物考古工作队，2002）。随着时间的推移，器物造型不断地增加，这是一个渐进的过程，从时代上看也是这样。至明清时期实际上是集大成，瓶、把件、佩、笔架、斧、香炉、印章、戈、项链、胸针、仿生动物、龙、鹰、马、羊、印章、笔舔、扳指、杯、凿、牌、水盂、镯、炉、锛、管、手串、杵、坠、挂件、璧、珠、观音、弥勒、童子、鼻烟壶、洗、手带、戒指、耳环、平安扣、隔片、隔珠、朝珠、佛像、多宝串、簪等都有见。每一个时代在造型上有着频现的造型，如清代玛瑙鼻烟壶非常盛行，占到玛瑙数量的相当部分；如当代的吊坠类也是这样，在数量上鹤立鸡群。

　　从规整上看，玛瑙造型在规整程度上通常比较好，多是造型隽永之器，这与古人的打磨认真，态度一丝不苟，以及当代现代化的琢磨有关。另外，从写实和写意上看，玛瑙造型在写实性上比较强，明清时期写意的作品比较常见，而当代玛瑙制品主要以写实为主，惟妙惟肖，写意作品只是偶见。

战国红执壶（三维复原色彩图）

从形制上看，玛瑙在形制上特征明确，不同时代在形制上不同。如新石器时代的玛瑙璜多是半圆形，我们来看一则实例，新石器时代玛瑙璜"M4：4，半圆形"（上海博物馆考古研究部，2002）。可见在造型上比较标准，符合"半璧为璜"的传统。玛瑙珠的造型以圆形为主。而新石器时代的玛瑙尖状器则是多呈现出"H4：1，三面聚缩呈锥尖"（成都市文物考古工作队，2002），可见实用性比较强，是一种实用器。而商代的玛瑙璜则是呈"87M15：44，扁圆形"（安徽省文物考古研究所等，1999）。可见与新石器时代还是有些区别，只不过这种区别多是较微小。

春秋战国时期玛瑙在造型上不断发展。如最常见的玛瑙珠，有见"ZK：8，圆柱形"（青州市博物馆等，2002）；同时也有见，战国玛瑙珠"球体"（淄博市博物馆，1999）。由此可见，玛瑙球的造型在向多样化的方向发展。其实，这一时期相当多的器物造型都是发展很快，主要原因是在摆脱了礼制束缚之后，器物造型获得了自由发展的空间。如战国时期的玛瑙环有的呈现出八棱形，有的则是呈现出扁圆形等。汉代玛瑙在造型的发展上更是复杂。以造型

玛瑙珠玉组佩·两周之际

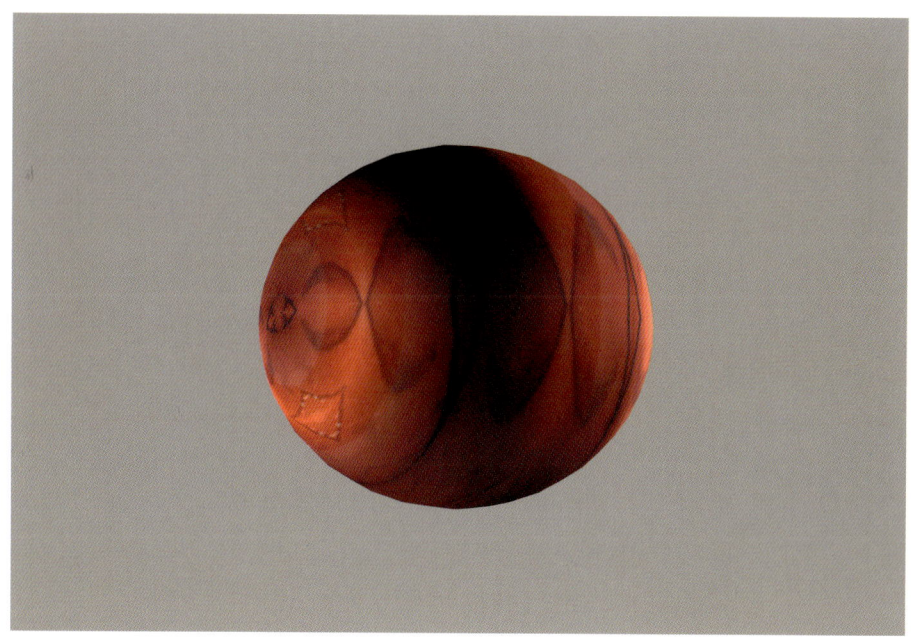

战国红珠（三维复原色彩图）

最简单的玛瑙球来看，西汉玛瑙珠"T1③：110，六棱形"（中国社会科学院考古研究所，2002）；同时还有见，西汉玛瑙珠"有圆形、橄榄形、六角形、八角形等"（广州市文物考古研究所，2003）。可见玛瑙珠在造型上几乎尝试了能够尝试的所有造型，造型之繁复令人叹为观止。东汉玛瑙基本上延续西汉在继续发展。六朝隋唐辽金玛瑙在造型上也是在延续传统的基础上不断发展。还以玛瑙珠为例，唐代的玛瑙珠造型更广，如"管状"（中国社会科学院考古研究所四川工作队，1998）。当然，这样的造型早期也有见，但将其作为玛瑙珠并且固化，显然应该是唐代较为正式。另外，还有见唐代玛瑙珠是"M2124：14，饼状"（黑龙江省文物考古研究所，2003），可见造型丰富之程度，几乎令人难以想象。宋元明清时期基本上也是这样，造型向着陈设装饰化的方向进一步发展。民国基本上也是以延续传统为显著特征。当代在延续传统的同时加入了诸多新元素。如车挂的造型在当代比较流行等，这种造型是以往很少见到的。从大小上看，玛瑙器皿在大小上特征并不明显，可以说是造型各异，大小不一，没有过于固定化的特征。这一点我们在鉴定时应注意分辨。

六、做　工

　　玛瑙在做工上多数精益求精，极尽心力，粗糙者少见。玛瑙的硬度很大，脆性相当强，所以要将玛瑙雕刻、琢磨是很难的事情。要将硬度很大的玛瑙制作完美，需要一丝不苟的态度。不同时代的玛瑙在做工上有所区别，但这种区别主要是在制作技术和习惯上，在态度上基本都是精益求精。

红玛瑙、和田玉白玉福瓜

从技术上看，新石器时代玛瑙"均采用间接打击法制作"（滦平县博物馆等，1998），在做工上还是比较原始；只有个别礼器类的器皿在做工上才较为复杂化。但是商代玛瑙在做工上就已经非常正规化了。我们来看一则实例，商代"在工艺上采用了阴刻、抛光、片切、

南红凉山料手链

浮雕、圆雕、透雕、钻、剪地法、线切、砣机旋磨、管钻、砣机切等技术"（安徽省文物考古研究所等，1999）。可见商代在玛瑙制作工艺上已经相当成熟，在钻孔方法上通常采取一面钻。战国时期在做工上基本延续前代，但做工显然是在发展。我们来看一则实例，战国玛瑙珠"中部有对钻穿孔"（淄博市博物馆，1999）。由此可见，战国时期的玛瑙珠是对钻的，不过不精致者也有见，我们来看一则实例，唐代玛瑙珠"加工不精"（中国社会科学院考古研究所四川工作队，1998）。可见的确有玛瑙加工不精的情况，但这种情况数量很少。明清乃至民国在做工上基本延续传统，无矫揉造作者，但如果有两件完全相同的制品，显然有一件是假的，也有可能二者皆假。

从纹饰上看，玛瑙在纹饰线条上以流畅、刚劲有力而著称，影响深远。但由于玛瑙比较硬，刻画和雕刻的难度都比较大，所以在古代往往不以纹饰取胜，而是以造型取胜。但是在当代由于机器雕刻的出现，玛瑙做工思路上也有了重大改变，就是造型和纹饰雕刻并举的方法，纹饰繁缛，有的时候甚至是繁复的情况都有见。鉴定时应注意分辨。

马达加斯加红玛瑙算珠

战国红玛瑙筒珠

南红凉山料算珠

南红凉山料算珠

七、功　能

玛瑙在功能上比较明确，如实用器、明器、首饰、项饰、佩饰、耳饰、陈设器、饰品、财富象征、艺术品、发饰等的功能都有见，不同的时期在功能上有所不同。

我们来看一则实例，新石器时代玛瑙"生产工具及饰件在各类遗存中"（湖南省文物考古研究所，2001）。可见，玛瑙在最初就同普通石头一样是一种制作农具和生产工具的原料，如石核、尖状器、镞、石片等，各种实用器皿都有见。而在新石器时代中晚期，就有许多如玛瑙璜等礼器性的造型出现了。

商代人们对于玛瑙的认识更为深刻，农具和工具的功能逐渐下降，礼器的功能上升。我们看一则资料，商代"器类有钺、斧、戈、玦、璧、环、璜、龙凤璜、镯、管、喇叭形坠饰、塔形饰、菌形饰、人、龙、鹰（腹部刻画圆圈和八角纹）等"（安徽省文物考古研究所等，1999），基本都是礼器性的造型。由此可见，玛瑙在商代，礼器意义上的功能上升到了一个顶点，同时装饰性的功能也是迅猛发展。西周时期基本也是这样，在功能上以明器、项饰、装饰、发饰等为主。

内蒙古阿拉善戈壁玛瑙摆件

战国红摆件

红玛瑙、和田玉组合手串

　　春秋战国由于礼制崩溃，玛瑙的礼器地位退到幕后，基本上确立了以陈设装饰为主，兼具有其他功能的发展思路。这一发展趋势历经秦汉，直至明清，乃至当代都没有改变。只是当代玛瑙的一些稀有品种，如南红、战国红等呈现更多的首饰、财富、艺术品的功能。

红玛瑙镯（三维复原色彩图）

绿玛瑙碟（三维复原色彩图）

第三章　色彩鉴定

玛瑙的色彩十分丰富，常见的玛瑙色彩有红、白、蓝、黄、紫、绿、黑、棕色等，但这只是大的色彩分类，在这些色彩中还有许多是小品种色彩，或者以这些色彩为基调的衍生色彩。如蓝白相间、黄白、

绿玛瑙镯（三维复原色彩图）

牙白、灰白、淡绿、暗灰、褐红、灰黄、绛紫、乳黄、墨绿、乳白、红褐、墨绿、乳白泛灰、深棕、浅棕、浅灰、橙红、褐、橘红、紫红、红褐、浅黄、褐黄、深红、天然条带杂色，等等。由此可见，玛瑙在色彩上是相当丰富，涉及了众多的色彩类别。从色彩纯正程度上看，玛瑙在色彩纯正程度上不是很好，真正纯正的玛瑙色彩很少见，主要是以相间或者是渐变色彩存在，以两种主要的色彩相互渐变为主。这与其自然矿物的属性相符。

马达加斯加红玛瑙籽料摆件

马达加斯加白玛瑙平安扣

工艺精湛的南红算珠

从数量上看，自然界中众多色彩的玛瑙，其实在数量上相差还是比较大的。如白玛瑙的数量就非常之多，而红玛瑙的数量相对来讲就比较少见，特别是珍贵的南红，如保山料数量就比较少。由此可见，玛瑙在数量上总体的特征是参差不齐。

从珍贵程度上，玛瑙的珍贵程度与色彩有着至关重要的联系。如白玛瑙在市场上因为数量很多，色彩普通，价值就很低。同样，黑玛瑙等也是这样。总之，大多数玛瑙价格都很低。唯独红玛瑙价格非常高，如南红、战国红的价格以克论价，十分珍贵，就是因为其色彩非常之好，在市场上受到人们的热捧。

水草花玛瑙镯（三维复原色彩图）

绿玛瑙摆件

战国红摆件

南红凉山料摆件

战国红摆件

南红凉山料摆件

 从时代上看，玛瑙色彩在时代上特征鲜明。不同时代对于玛瑙色彩的喜好不同。不过，时代越早，在玛瑙色彩上越是丰富，而越晚则是相反。从精致程度上看，玛瑙色彩与精致程度有一定的关系。南红和战国红在工艺上多是比较精致，特别是品质高的南红，做工精细，精益求精，多数是精美绝伦的艺术品；而其他杂色在精致程度上就不会很高。

战国红摆件

南红玛瑙珠

战国红摆件

第一节　新石器时代玛瑙

　　新石器时代玛瑙在色彩上十分丰富，各种各样的色彩都有见。我们来看一则实例，新石器时代玛瑙珠"95TZM134 ： 1，用红色玛瑙石磨制而成"（青海省文物管理处等，1998）。这件玛瑙珠是用天然红色玛瑙磨制而成，非常的漂亮，可见红色在新石器时代就有利用，而不仅仅是当代喜欢红色。不过新石器时代在色彩上显然是没有我们当代如此固定化到红色，其在色彩上是多元化的，红色的实例也是偶见。我们再来看一则实例，新石器时代玛瑙璜"M4 ： 4，黄白色玛瑙质"（上海博物馆考古研究部，2002）。这是一件黄白色的复色玛瑙璜，而且制作的是在当时十分重要的礼器璜的造型。这说明，在新石器时代并没有我们当代色彩以红色为贵的概念。另外，灰白色的玛瑙在当时也比较常见，如新石器时代玛瑙玦"AT01 ② ： 7，灰白色玛瑙"（广西壮族自治区文物工作队等，2003）。这不是一个孤例，而是数量比较丰富。总之，新石器时代玛瑙在色彩上是多样化的，不同的色彩都出现了，完全是玛瑙的自然属性，人们并没有选择性的色彩，或者说根本没有关注色彩，而主要关注的是器物造型等。我们再来看一则实例，新石器时代玛瑙"颜色有乳白、暗红、淡绿、暗灰色等"（滦平县博物馆，1998）。由此可见，新石器时代玛瑙在色彩上的繁荣程度，诸色都有见。

马达加斯加红玛瑙圆珠

战国红摆件

玛瑙执壶（三维复原色彩图）·西周

第二节 商周秦汉玛瑙

一、商代玛瑙

商代玛瑙在色彩上基本延续新石器时代特征。我们来看一则实例，商代玛瑙斧"M28：21，绛紫色"（安徽省文物考古研究所等，1999），同时在此次发掘中还出土了"商代玛瑙钺M20：1，含黑色花斑""商代玛瑙璜87M15：44，乳黄色""商代玛瑙环T1004③：1，乳白色"等。由此可见，在商代，诸色玛瑙都有见，但主要是以主流色彩的衍生为主，也就是复杂为主，在色彩纯正程度上也不是很好，相互串色的情况很常见。如上例中的玛瑙钺内含有大量的黑色花斑。

二、西周玛瑙

西周时期的玛瑙在色彩上也是各种色彩都有见。我们来看一则实例，西周玛瑙璜"M119：26，淡黄色玛瑙质"（中国社会科学院考古研究所山东工作队，2000）。可见，淡黄色玛瑙是西周时期的重要色彩，而这种色彩显然是传统的延续。不过西周时期玛瑙在色彩上显然已经是有所选择，这一点主要从一些高级的墓葬当中可以看到。如七璜联珠组玉佩出土于M2001号虢国国君大墓，共由374件的器物组成，整组玉佩分为上下两部分，上部为玛瑙珠、玉管组合项饰；下部用玉璜、玛瑙珠和料珠组合。上部由122件组成。1件人龙合纹玉佩、18件玉管、103颗红玛瑙珠串联组成。其中，14件长方形玉管两两并排地分别串联在两行玛瑙珠之间，另外4件呈现单行串联于其间。后者显然是为了避免两行串珠分离而起约束作用。玉佩位于墓主人颈后中部，为项饰的枢纽，展开长度约为53厘

米，出土于墓主人的颈部。下部共计252件，由7件玉璜由小到大与纵向排成双排四行对称的20件圆形玛瑙管、117颗玛瑙管形珠、108颗菱形料珠相间串联而成。20件玛瑙管分为10组，每2件成1组。料珠为18组，每组为6颗。玛瑙珠分为16组，2颗、4颗、13颗不等为1组，统一作并排两行，以青白色玉璜为主色调，兼以红、蓝二色，出土于墓主人胸及腹部（姚江波，2009）。七璜联珠组玉佩是出自虢国国君的墓葬当中，用于穿系的103颗玛瑙珠也都是红色的。笔者曾作为该博物馆内文物库房保管员，研究这批文物得知，这些玛瑙珠与当代的天然红玛瑙不同，多数不是天然的，是经过焙烧而成为红色。由此可见，红色的玛瑙珠在西周时期已经成为一种风尚，人们要刻意去"作红"它。与当代有区别的是，西周时期在崇尚红色玛瑙的同时并不排挤其他色彩的玛瑙，红色与其他色彩是共生的关系。这是西周玛瑙在色彩上的核心内容。从色彩纯正程度上看，基本也是这样。虢国墓内经过焙烧的玛瑙在色彩上达到了相当纯正的程度。而其他墓葬出土的一些如黄白色等的玛瑙在色彩上则是十分复杂，几乎谈不上纯正程度。由此可见，在色彩纯正程度上也是纯正与复色兼具。以上特点我们在鉴定时应注意。

红玛瑙珠链·西周

三、春秋玛瑙

春秋时期玛瑙在色彩上基本延续西周时期。我们来看一则实例，春秋玛瑙项链"M3：28，以红色为多"（山东大学考古系，1998）。由这件实例可见，的确在春秋时期红色依然是具有很大的影响力，但是其他色彩也有见，并不排斥。另外，大型组玉佩在春秋时期继续发展，达到鼎盛。有关文献记载组玉佩的内容很多，如《周礼·天宫冢宰·王府》："佩玉上有葱衡，下有双璜，冲牙，珍珠以纳其间。"《大戴礼·保傅》载："上有双衡，下有双璜、冲牙、蚍珠以纳其间。"可见春秋组玉佩的兴盛，这些组玉佩的制作和造型基本都模仿西周时期，所以用于穿系的玛瑙通常也都是红玛瑙，只是在工艺上比西周时期差了许多。显然，西周时期礼器一样的制品再也无法维系了。不过，由此也可以看到红玛瑙对于春秋玛瑙在色彩观上的影响还是深刻的，不然也不会出现上例中的玛瑙项链以红色为多的现象。这一点我们在鉴定时应注意分辨。

玛瑙珠、玉管组合发饰·西周

玛瑙珠玉组佩·西周

南红凉山料标本

绿玛瑙标本

四、战国玛瑙

战国时期，玛瑙在色彩上有一些倒退，像虢国墓那样纯正的红色玛瑙数量少了，多是一些杂色。我们来看一则实例，战国玛瑙环"墨绿色"（长沙市文物考古研究所，2003）。可见色彩极为不纯正，存在着墨色到绿色的渐变，而且常常伴随着一些大块杂色斑点，如"夹杂有乳白色斑块"（长沙市文物考古研究所，2003）等。总之，像这样的情况非常多见，如战国玛瑙珠"呈乳白、红褐、墨绿诸色"（淄博市博物馆，1999）。可见其色彩之复杂性。但是，真正红色的玛瑙实例不是很好找到，这一点我们在鉴定时应注意分辨。这可能与战国时期连年互伐，民财匮乏，从而影响到了对于玛瑙的深加工等有关。

五、西汉玛瑙

秦汉玛瑙基本上继承了前代特征。我们来看一则实例，西汉玛瑙印章"M102：32，浅黄色玛瑙质"（扬州博物馆等，2000）。再来看一则实例，西汉玛瑙"一种呈深棕色或浅棕色"（广州市文物考古研究所，2003）。由此可见，西汉玛瑙在色彩多样化特征上的确是较为复杂，各种各样的色彩都出现了，依然是延续着传统。但我们可以看到，在色彩纯正程度上，主要是以深棕色和浅棕色为主，其渐变色彩的程度逐渐在减弱。这说明，西汉时期人们对于玛瑙料进行了粗略的选择。而且在西汉时期还出现了自春秋以后就很少见到的红色。我们来看一则实例，西汉玛瑙珠"一种呈橘红色"（广州市文物考古研究所，2003）。可以想象这颗橘红色的玛瑙珠在当时一定是非常艳丽。可以说西汉时期是玛瑙在颜色上的一个恢复，特别是对于红色和纯色的复兴。这一点我们在鉴定时应注意分辨。

六、东汉玛瑙

东汉时期玛瑙在色彩上特征十分明确，依然延续西汉时期的特点继续发展。总体上是以红色基调为重，兼顾其他色彩，这一点很明确。我们来看一则实例，东汉"7 件棕色、橘红色榄形玛瑙"（广西壮族自治区文物工作队等，2003）。可见在色彩上是以红色较为深的颜色橘红为基本色彩。从数量上看，这种色彩在东汉时期也是经常有见，有一定的量。不过这种色彩显然为传统的延续。再来看东汉时期较为纯正的红色，东汉玛瑙组合串饰"M5：67，红色"（广西壮族自治区文物工作队等，2003）。但是，通常情况下纯正的红色不是很常见，不过由此可见，东汉时期玛瑙在色彩上已经是在追求纯正的红色。从兼顾色彩上看，东汉玛瑙在追求传统红色的同时，并不排斥其他的色彩，而是在兼顾。来看一则实例，东汉"包括褐色、橘红色长橄榄形玛瑙饰 8 件"（广西壮族自治区文物工作队等，2003）。可见，东汉时期玛瑙在色彩上的确是比较丰富，涉及众多的色彩种类。从色彩的纯正程度来看，东汉玛瑙在色彩纯正程度上不懈追求，这一点不仅仅是从红色上可以看出，而且还涉及了白色、黑色等。我们来看一则实例，东汉玛瑙珰"白色"（广西壮族自治区文物工作队，2002）。另外，马鞍岭东汉墓还出土了"黑色"的玛瑙制品。可见，当时人们对于玛瑙的认识已经十分深刻，黑色的玛瑙其实是较难以辨别，很多人不识。

红玛瑙标本

红玛瑙镯（三维复原色彩图）·春秋

　　总之，汉代玛瑙在色彩上是多色并存，主攻红色，兼顾诸色。
关于这一点我们来看一则实例，汉代玛瑙长方形扣饰"有白、浅灰、
红、橙红、深红色等"（云南省文物考古研究所等，2001）。可见
汉代玛瑙长方形扣饰在色彩上主要是红色调的渐变色，同时有灰、
白等色，在色彩差距上比较大。从色彩的复杂程度上看，汉代玛瑙
色彩复杂与简单并存，这一点很明确。如红色中的纯色或是橘红色
等，在色彩上追求的是纯正，色彩比较简单，这是一个方面；而另
一方面表现的是比较复杂，我们来看一则实例，汉代玛瑙长方形扣
饰"部分夹有不同颜色的天然条、带纹"（云南省文物考古研究所
等，2001）。可见充满了条带纹，不同的颜色相互融合，又相互分离，
并交织在一起。

　　由此可见，商周秦汉时期的玛瑙在色彩上特征还是比较清楚，
就是多种色彩并行，但显然是将红色置于突出位置。

第三节 六朝隋唐辽金玛瑙

一、六朝玛瑙

　　六朝玛瑙在色彩上多数为传统的延续。我们来看一则实例，六朝玛瑙管"F2：38，红褐色"（黑龙江省文物考古研究所，2003）。由上可见，这件器物在色彩上是一种复色，红色与褐色的渐变色彩，应该主要是延续传统，因为它基本上也算是红色基调的衍生色彩。其实，这一时期红色为重的特点依然是比较浓重。再来看一则实例，六朝玛瑙珠"M1：17，紫红色微透明"（老河口市博物馆，1998）。这样的色彩与我们当代的南红实际上相似。可见在六朝时期虽然深受限制厚葬之风的影响，但在玛瑙颜色的选择上古人依然是非常重视，红色在六朝时期玛瑙当中所占比例很重。但因为本身玛瑙原料在来源上没有太大改变，所以玛瑙其他色彩也有见。

南红凉山料摆件

二、隋唐五代玛瑙

隋唐五代玛瑙在色彩上坚持了自汉代以来崇尚的红色。我们来看一则实例，五代玛瑙珠"橘红色"（西藏自治区山南地区文物局，2001）。可见，这件玛瑙珠是以红色为基调，但这样的色调并未能在唐代占据统治地位，而且在色彩上可能比其他时代更为分散，这主要是由于原料的限制所导致。我们再来看一则实例，唐代玛瑙珠"浅黄色"（黑龙江省文物考古研究所，2001），浅黄色的玛瑙显然在原料上也就是来自当地。还有如唐代玛瑙珠"M1：6，棕色带褐黄色"（中国社会科学院考古研究所四川工作队，1998），这件玛瑙珠我们可以知道它的使用地是四川，虽然和四川凉山料是一个省份，但当时人们还没有发现凉山料，所以这件玛瑙珠选择了棕色为基调，且略带些褐黄色。由此可见，隋唐五代时期人们对于玛瑙在色彩上更加多元化，犹如一个新的开端，很重视红色 ，但并不唯有红色。

三、辽金玛瑙

辽金玛瑙在色彩上受到唐代影响比较重，在色彩上多元化趋势也是比较严重，但显然没有唐代严重。辽代玛瑙主要还是延续了汉代以来红色玛瑙为重的特点。我们来看一则实例，辽代玛瑙，圆柱形管"呈深红色"（中国社会科学院考古研究所内蒙古工作队，2003）。由此可见，深红色的玛瑙在辽代有见。实际上这并不是一个孤例，而的确是辽代玛瑙有红色的色彩倾向性，或许这也印证了有些少数民族地区在保持传统方面可能更能保持原始的风貌。金代玛瑙在色彩上与辽代很相似，基本上也是传统的延续，创新很少，在这里不再赘述。

南红凉山料手链

马达加斯加红玛瑙平安扣

第四节 宋元明清玛瑙

一、宋元玛瑙

宋元时期的玛瑙制品在色彩上基本还是传统的延续，诸多色彩都有见，包括红色及衍生色彩都有见，但并不排斥其他色彩的存在。各色并举的发展趋势依然强劲，但红色显然是人们比较喜欢的一种色彩，在出现的频率上比较高。之所以宋元时期在玛瑙色彩上没有改变，显然是在宋元时期由于人们关注点比较多，玛瑙在那个时期只是作为一种中低档玉石类，其本身材质地位已经比以往有所降低，所以在色彩上并没有引起人们很多关注的目光。由此可见，自西汉玛瑙色彩向红色为重的方向发展以来并不顺利，在东汉时期几乎红色达到相当地位的时候，被魏晋南北朝的限制厚葬打击了一下。之后再进入隋唐五代时期，乃至宋元时期由于材质地位的下降，均未受到太多的关注，这一线索的梳理我们在鉴定时应注意分辨。

红玛瑙执壶（三维复原色彩图）·清

二、明清玛瑙

明清玛瑙在色彩上依然坚持传统，各种色彩都有见。这一点从清代传世下来的玛瑙制品上可以清楚地看到。如类似黄龙玉水草花一样的玛瑙印章在清代就比较常见。看来这种以半透的灰白色为主，上面有很多黑色和褐色斑点，与水草很相像的玛瑙色彩，在清代也能受到人们的青睐。另外，白色的香炉也是清代玛瑙制品中常见到的。实际上，这种质地现代矿物学认为应该是白玉髓，但是清代人可能认为是玛瑙。还有一些黄褐色、棕黄色、紫红色、红棕色，包括一些俏色的玛瑙雕件都很常见。由此可见，明清玛瑙在色彩上同样是异彩纷呈，分外妖娆。但是，我们发现，在清代已经有专门的南红作品，非常的漂亮，而且红色的玛瑙雕件明显偏多。虽然多数不是南红料，但由此我们可以看到，至迟在清代，玛瑙自汉代以来对于红色的追求已经明朗化，也就是有以红色为贵的趋势。但显然这种趋势在明清时期无法像我们当代一样固定化，因为当时红色玛瑙的资源很有限，且传统延续的力量非常强大，这一点我们应能理解。

红玛瑙镯（三维复原色彩图）·清

绿玛瑙碟（三维复原色彩图）

第五节　民国及当代玛瑙

一、民国玛瑙

民国玛瑙色彩基本延续清代，各种色彩都有见。虽然人们最喜欢红色，包括南红的作品也是频现，但南红资源已几近枯竭，因此，始终没能像当代一样如此明确地确定以南红为追求目标。这一点我们在鉴定时应注意分辨。由于民国玛瑙在色彩上和清代没有太大变化，创新也很少，所以在这里就不再过多赘述。

二、当代玛瑙

当代玛瑙在色彩上特别丰富，红、白、蓝、黄、紫、绿、黑、棕，以及这些色彩的衍生色彩，蓝白相间、黄白、牙白、灰白、淡绿、暗灰、褐红、灰黄、绛紫、乳黄、墨绿、乳白、乳白泛灰、深棕、浅棕、浅灰、橙红、褐、橘红、紫红、红褐、浅黄、褐黄、深红色等，可以说都有见，从色彩丰富的程度上可谓是集大成。但是，当代玛瑙在色彩上也具有极为鲜明的特点，就是将自汉代以来屡次有发展的红玛瑙发展至顶峰，确立了以红色为贵的色彩发展体系。当然，在这一体系中并不是所有的红玛瑙都很贵重，而是以南红为主。在北方地区确立了以战国红的色彩为贵的体系。其他诸多色彩的玛瑙多在低档的玛瑙市场徘徊，而且出现的频率在逐渐降低。这就是当代玛瑙的基本现状，我们在鉴定时应注意。

战国红摆件

玛瑙原石摆件

战国红摆件

南红云南保山杨柳料标本

南红保山杨柳料标本

1. 南红保山料

南红保山料在色彩上以柿子红为显著特征。这一名称非常的贴切，这点无论老料和新料都是这样，色彩特别稳定，雕件几乎是通体一色，在纯正程度上，非常难得。因为我们知道，一般玛瑙在色彩上是喜串色的，所以这就更显得保山料之俊美了。这种色彩可以雕刻出相当完美的雕件，是古代和当代玛瑙收藏中所追求的。同时，南红保山料在色彩上也比较容易辨识，柿子红的色彩几乎成为了南红保山料的一张名片。一看到这样的色彩，人们就知道是保山南红，鉴定时应注意分辨。

南红保山杨柳料执壶（三维复原色彩图）

南红凉山料手链

2. 南红凉山料

凉山南红在色彩上比较复杂，虽然是红色，但以红色为基调的色彩变化比较丰富。如朱砂红、血红、柿子红、红白料、玫瑰红、紫红、辣椒红等都有见，可见其在色彩上变化之丰富。在色彩纯正程度上，如红白料显然是红色与白色的渐变色，而且最终红色与白色必见分晓，也就是红白分明。当然，这是凉山料最为严重的一种渐变色彩，虽然不可否认这是一种美，但我们透过这一点也可以看到南红凉山料在色彩上是渐变的，只不过有的严重，有的不严重而已。如血红色在渐变上就不严重，但是仔细观察还是可以看到渐变的痕迹，这也是南红凉山料在价格上比保山料低很多的原因之一。因为有的人认为这是优点，但是有的人认为这是缺点。色彩纯正是辨别优劣的唯一标准，至于是优点还是缺点只有市场来评论，本书在这里不评论，只是论述其色彩的特征。

南红凉山料摆件　　　　　南红凉山料珠　　　　　　　　南红凉山料摆件

战国红摆件

战国红摆件

战国红碟（三维复原色彩图）

3. 战国红

战国红在色彩上可谓是丰富到了极点，正如它的名字一样，是各种色彩相互竞技的场所。常见的色彩有红、绿、黑、棕、白、蓝、黄、紫、灰黄、乳黄、鸡油黄、土黄、乳白、红褐、柠檬黄、深棕、浅棕、浅灰、橙红、褐、橘红、紫红、红褐、浅黄、褐黄、深红、血红、朱砂红、鸡血红等诸色，可见色彩之丰富。总之在色彩上几乎是没有定式，战国红的色彩没有完全相同的，当然有的是比较接近。而在如此众多的色彩中，目前市场认为比较好的依然是纯色。如红色、黄色等都是目前市场所追捧的，红黄交织在一起的色彩最为吸引人。总之，战国红在色彩上目前的定位还是不太明确，这可能与其被人们关注的时间太短有关系。相信随着时间推移，战国红究竟是哪一种色彩为贵，一定会进一步明确起来。

战国红算珠

战国红摆件

第四章　识市场

第一节　逛市场

一、国有文物商店

国有文物商店收藏的玛瑙具有其他艺术品销售实体所不具备的优势。一是实力雄厚；二是古代玛瑙数量较多；三是中高级专业鉴定人员多；四是在进货渠道上层层把关；五是国有企业集体定价价格不会太离谱。国有文物商店是我们购买玛瑙的好去处。基本上每一个省都有国有的文物商店，是文物局的直属事业单位之一。下面我们具体来看表 4-1。

红玛瑙摆件

南红凉山料摆件

表 4-1 国有文物商店玛瑙品质优劣表

名称	时代	品种	数量	品质	体积	检测	市场
玛瑙	高古	极少	极少	优/普	小器为主	通常无	国有文物商店
	明清	稀少	少见	优/普	小器为主	通常无	
	民国	稀少	少见	优/普	小器为主	通常无	
	当代	多	少	优/普	大小兼备	有/无	

红玛瑙执壶（三维复原色彩图）·春秋

　　由表 4-1 可见，从时代上看，国有文物商店玛瑙古代有见，但比明清时期早的玛瑙很少见。而我们知道玛瑙在新石器时代就已是相当流行，历经商周秦汉直至当代。如新石器时代玛瑙"璜 1 件"（上海博物馆考古研究部，2002），由此可见，良渚文化时期就已经普遍使用玛瑙。但这些玛瑙多是随葬在墓葬当中，出土后很多都保存在博物馆中。而明清时期距离现在时间比较近，而且传世品比较多，所以遗留下来的比较多，在国有的文物商店内较为常见。民国延续明清；当代玛瑙达到了鼎盛。

红玛瑙摆件

南红云南保山杨柳料

南红保山杨柳料标本

战国红摆件

从品种上看，古代玛瑙品种并不多，直至民国时期都是这样。而当代玛瑙在品种上比较齐全，如红色、黄色、蓝色、黑色、棕色、褐色、绿色玛瑙等都有见。

从数量上看，国有文物商店内的高古玛瑙极为少见，主要是明清及民国时期有见，但数量也是比较少。明清玛瑙以保山料南红为最好。只有当代玛瑙在数量上比较多见，可以说是应有尽有，在优质料上不仅有传统的南红保山料，而且也有四川凉山料及北方的战国红等。总之，当代玛瑙在原料上具备来源充足性的特点。从品质上看，高古玛瑙在品质上较为优良，但更多是普通质地的玛瑙；当代玛瑙在品质上优质者众多，主要以南红和战国红为多见，普通者也有见，但数量很少。

从体积上看，国有文物商店内的玛瑙高古、明清、民国都是以小器为主。这其实并不是完全因为原料稀缺的问题，对于玛瑙而言并不能说原料过于稀少，主要是由于玛瑙硬度极大，很难加工等原因综合造成的。当代玛瑙随着有现代化的技术作为支撑，在体积大小上已经不是问题，形成大小兼备的格局。但对于一些南红作品来讲，还是以小件为主。如保山南红就很难出大料，这一点我们在鉴定时应注意分辨。

从检测上看，古代玛瑙通常没有检测证书，而当代玛瑙有的有检测证书。但玛瑙的检测证书其实只能说明是玛瑙，而并不能说明玛瑙的优劣。对于玛瑙而言，检测证书其实并非是鉴定的万能良药。

内蒙古阿拉善戈壁玛瑙摆件

马达加斯加红玛瑙籽料执壶（三维复原色彩图）

二、大中型古玩市场

大中型古玩市场是玛瑙销售的主战场。如北京的琉璃厂、潘家园等，以及郑州古玩城、兰州古玩城、武汉古玩城等都属于比较大的古玩市场，集中了很多玛瑙销售商。像北京的报国寺，只能算是中型的古玩市场。下面我们具体来看一下表4-2。

表4-2 大中型古玩市场玛瑙品质优劣表

名称	时代	品种	数量	品质	体积	检测	市场
玛瑙	高古	极少	极少	优／普	小	通常无	大中型古玩市场
	明清	稀少	少见	优／普	小器为主	通常无	
	民国	稀少	少见	优／普	小器为主	通常无	
	当代	多	多	优／普	大小兼备	有／无	

战国红摆件

战国红摆件

阿拉善戈壁玛瑙镯（三维复原色彩图）

绿玛瑙镯（三维复原色彩图）

　　由表 4-2 可见，从时代上看，大中型古玩市场的玛瑙在时代特征上比较明确，古代、明清、民国和当代都有见，只是古董玛瑙比较稀少，而当代玛瑙数量比较多而已。

　　从品种上看，玛瑙在古代比较单一，主要以普通玛瑙为主，而当代玛瑙在种类上细化，以南红保山料、凉山料及北方流行的战国红玛瑙为多见。

南红凉山料手链

南红凉山料圆珠　　　　　　　　南红凉山料圆珠

　　从数量上看，高古玛瑙在文物商店内出现的几率极低，基本上以明清及民国时期为主，但数量也是比较少。当代大中型古玩市场内的玛瑙比较多，店铺内琳琅满目，雕件、串珠、山子、佛像等应有尽有，很多都是批发的门店。但主要是经营南红及战国红玛瑙。

　　从品质上看，玛瑙在品质上无论是古代还是当代，基本上都是以优良为主；但是普通者也有见，特别是当代尤其重视南红当中的优质料。

　　从体积上看，大中型古玩市场内的玛瑙古代以小件为主，很少见到大器；而当代的玛瑙在体积上则是大小兼备，但南红除外，特别是南红玛瑙优质料真的是太少了，所以客观上很难出大器。

战国红摆件

南红凉山料算珠

南红凉山料算珠

从检测上看，古代玛瑙进行检测的很少见；但是当代玛瑙，特别是珍贵的南红，基本上都进行检测，而且有很多本身附带有检测证书。

南红凉山料镯（三维复原色彩图）

三、自发形成的古玩市场

这类市场三五户成群，大一点几十户。这类市场不很稳定，有时不停地换地点，但却是我们购买玛瑙的好地方。我们具体来看一下表4-3。

表4-3 自发古玩市场玛瑙品质优劣表

名称	时代	品种	数量	品质	体积	检测	市场
玛瑙	高古						自发古玩市场
	明清	稀少	少见	普／劣	小器为主	通常无	
	民国	稀少	少见	普／劣	小器为主	通常无	
	当代	多	多	优／普	大小兼备	通常无	

马达加斯加红玛瑙籽料镯（三维复原色彩图）

　　由表 4-3 可见，从时代上看，自发形成的古玩市场上的玛瑙明清时期有见；高古玛瑙不能说没有真货，但真的是如大海捞针一般；以当代玛瑙为多见。从品种上看，自发古玩市场上的玛瑙明清和民国时期品种都很少见，以当代的南红最为常见。从数量上看，明清民国都很少见，主要以当代为多见。从品质上看，明清和民国时期，普通和低劣的产品都有见，精致者很少见；但是当代南红主要以优良料和普通者为主。从体积上看，明清及民国基本以小器为主，当代则是大小兼备。这主要是由于当代玛瑙原材料大量增加，特别是战国红及凉山南红的发现，使得南红变得原料充足。从检测上看，这类自发形成的小市场基本上没有检测证书，全靠收藏者自己的眼力辨别。

水草花玛瑙筒珠

马达加斯加白玛瑙平安扣

四、大型商场

大型商场内也是玛瑙销售的好地方。因为玛瑙本身就是奢侈品，同大型商场血脉相连。大型商场内的玛瑙琳琅满目，各种玛瑙应有尽有，在玛瑙市场上占据着主要位置。下面我们具体来看一下表4-4。

表4-4 大型商场玛瑙品质优劣表

名称	时代	品种	数量	品质	体积	检测	市场
玛瑙	高古						大型商场
	当代	多	多	优／普	大小兼备	通常无	

红玛瑙摆件

黑玛瑙摆件

绿玛瑙摆件

战国红摆件

由表 4-4 可见，从时代上看，大型商场内的玛瑙以当代为主，古代基本没有。从品种上看，大型商场内玛瑙的种类非常多，以珍贵的南红和战国红为主。如云南保山料南红、四川凉山料南红，战国红也是不同地方的都有见。从数量上看，南红玛瑙非常多，可选择性比较大。从品质上看，大型商场内的玛瑙在品质上多是南红中的精品，普通的也少量有见，但是粗者几乎很少见。虽然价格不菲，但品质有保障。从体积上看，大型商场内玛瑙大小兼备，大到山子、摆件，小到摆件、串珠等都有见。因为从计价方式上看，当代玛瑙主要是以称重计价，越重的玛瑙价格越高，这也促使了南红玛瑙向大器的改变。从检测上看，大型商场内的玛瑙由于比较精致，十分贵重，多数有检测证书。

五、大型展会

大型展会，如玛瑙订货会、工艺品展会、文博会等成为玛瑙销售的新市场。下面我们具体来看一下表 4-5。

表 4-5 大型展会玛瑙品质优劣表

名称	时代	品种	数量	品质	体积	检测	市场
玛瑙	高古						大型展会
	明清	稀少	少见	优／普	小器为主	通常无	
	民国	稀少	少见	优／普	小器为主	通常无	
	当代	多	多	优／普	大小兼备	通常无	

绿玛瑙执壶（三维复原色彩图）

马达加斯加红玛瑙碟（三维复原色彩图）

马达加斯加玛瑙碟（三维复原色彩图）

由表 4-5 可见，从时代上看，大型展会上的玛瑙，明清、民国时期多见，但总量不大，主要以当代为主。从品种上看，大型展会上的玛瑙品种比较多，以战国红和南红玛瑙为主。从数量上看，各种玛瑙琳琅满目，数量很多，各个批发的摊位上可以看到用大麻袋装的串珠、挂件等。从品质上看，大型展会上的南红及战国红玛瑙在品质上可谓是优良者有见，更有见普通者，但是低等级的玛瑙很少见。从体积上看，大型展会上的古代玛瑙在体积上大小都有见，不过主要还是以小器为主；但是当代玛瑙则是大小兼备。从检测上看，大型展会上的玛瑙多数无检测报告，只有少数有检测报告，但也只能证明是玛瑙，至于具体的品质则无法检测。

马达加斯加红玛瑙平安扣

六、网上淘宝

网上购物近些年来成为时尚，同样在网上也可以购买玛瑙。上网搜索，会出现许多销售玛瑙的网站。下面我们具体来看一下表4-6。

表4-6　网络市场玛瑙品质优劣表

名称	时代	品种	数量	品质	体积	检测	市场
玛瑙	高古	极少	极少	优／普	小	通常无	网络市场
	明清	稀少	少见	优／普／劣	小器为主	通常无	
	民国	稀少	少见	优／普／劣	小器为主	通常无	
	当代	多	多	优／普	大小兼备	有／无	

南红凉山料摆件

马达加斯加红玛瑙籽料摆件

马达加斯加红玛瑙算珠

　　由表4-6可见，从时代上看，网上淘宝可以很便捷买到各个时代的玛瑙，随意搜索"时代名称＋玛瑙"即可。但是通常情况下，新石器时代的玛瑙等多数是伪器，因为从来源上就说不通。高古的玛瑙制品应该多数都在博物馆中，所以网络市场上如果说有真的，也是以明清、民国时期为主。因为这一时期玛瑙传世品很多，在农村比较容易找到。不过，在网上找到的可能性真的不是很大。从品种上看，玛瑙的品种极全，几乎囊括所有的玛瑙品类，包括南红及战国红的名品等。从数量上看，各种玛瑙的数量也是应有尽有，只不过相对来讲，人们最喜欢红玛瑙。从品质上看，玛瑙的品质高古以优良和普通为主；明清、民国时期则是优良、普通、粗劣者都有见；当代则是以优良和普通为多见，粗劣者几乎不见。这说明当代玛瑙在质量上有了质的飞跃。从体积上看，高古玛瑙绝大多数是小器；明清、民国时期体积有所增大，但依然是以小器为主；当代玛瑙在体积上有很大进步，大小兼备的格局已形成。从检测上看，网上淘宝而来的玛瑙大多没有检测证书，只有一少部分有检测证书，但也多限于南红等。

南红凉山料摆件

七、拍卖行

玛瑙拍卖是拍卖行传统的业务之一。因此，拍卖行是我们淘宝的好地方。具体我们来看下表 4-7。

表 4-7　拍卖行玛瑙品质优劣表

名称	时代	品种	数量	品质	体积	检测	市场
玛瑙	高古	极少	极少	优／普	小	通常无	拍卖行
	明清	稀少	少见	优良	小器为主	通常无	
	民国	稀少	少见	优良	小器为主	通常无	
	当代	多	多	优／普	大小兼备	通常无	

南红凉山料摆件

南红凉山料摆件

马达加斯加红玛瑙籽料执壶（三维复原色彩图）

　　由表 4-7 可见，从时代上看，拍卖行拍卖的玛瑙各个历史时期的都有见，但高古玛瑙多是偶见，而以明清和民国及当代玛瑙为主。从品种上看，拍卖市场上的玛瑙在品种上比较齐全，以各种彩色玛瑙为显著特征，红色的玛瑙是主角。当然，这是因为其价格相对较高。从数量上看，高古玛瑙罕见有拍卖；而明清、民国时期比较多见；但是相对于当代还是属于绝对的少数。从品质上看，高古玛瑙优质、普通的质地都有见；而明清、民国时期的玛瑙主要是以品质优良的保山南红为主；当代玛瑙在拍卖场上则是以优良和普通的南红及战国红为主。从体积上看，古代玛瑙在拍卖行出现也是无大器，只是偶见大器；当代玛瑙在体积大小上则是有很大进步，大小兼备。从检测上看，拍卖场上的玛瑙一般情况下也没有检测证书，个别当代玛瑙有检测证书。

南红凉山料摆件

南红凉山料摆件

战国红筒珠

八、典当行

典当行也是购买玛瑙的好去处。典当行的特点是对来货把关比较严格，一般都是死当的玛瑙制品才会被用来销售。具体我们来看下表4-8。

表4-8　典当行玛瑙品质优劣表

名称	时代	品种	数量	品质	体积	检测	市场
玛瑙	高古	极少	极少	优／普	小	通常无	典当行
	明清	稀少	少见	优良	小器为主	通常无	
	民国	稀少	少见	优良	小器为主	通常无	
	当代	多	多	优／普	大小兼备	有／无	

战国红隔片

战国红摆件

南红凉山料镯〔三维复原色彩图〕

　　由表 4-8 可见，从时代上看，典当行的玛瑙古代和当代都有见。明清和民国时期的制品虽然不是很多，但也是时常有见；主要以当代为多见。从品种上看，典当行高古玛瑙的品质不是很好；而明清时期基本上就是以南红保山料为主；当代玛瑙品种极为丰富，几乎涉及传统的南红保山料、四川凉山料，以及北方的战国红料等。从数量上看，高古玛瑙的数量极少，明清和民国时期的玛瑙也是比较少见，只有当代比较珍贵的南红玛瑙在典当行是比较常见，是销售的主流。从品质上看，典当行内的玛瑙古代以优质和普通者为常见；当代在玛瑙品质上以精品为主，而且有很多都是名家雕刻，也有部分是普通品，但品质差者几乎不见。从体积上看，古代玛瑙的体积一般都比较小，很少见到大器；当代玛瑙已是大小兼备，但典当行内以小器为主。从检测上看，典当行内玛瑙很少有检测证书，但对于玛瑙而言一般情况下在典当行很难买到假货，在这一点上应该比较放心。

第二节　评价格

一、市场参考价

　　玛瑙具有很高的保值和升值功能，不过玛瑙的价格与时代以及工艺的关系密切。玛瑙虽然在新石器时代就有见，商周时期亦很流行，常见随葬于贵族大墓中，但由于当时人们对于玛瑙的认识和开采能力有限，并未能够对南红等玛瑙有过深认识，多是焙烧使玛瑙变红。汉唐以降，直至当代，玛瑙都非常流行，无论宫廷和市井都趋之若鹜。明清及当代以南红和战国红为重，质优者价格很高，特别是当代玛瑙此二者之外皆普通。人们以能够收藏到南红玛瑙为荣，而其他玛瑙则多是入门级。

　　南红的价格近些年来可谓是一路所向披靡，青云直上九重天。如汉唐玛瑙几百万者多见，但明清玛瑙也有数十万至上百万者。由上可见，玛瑙的参考价格也比较复杂。

红玛瑙镯（三维复原色彩图）·春秋

内蒙古阿拉善戈壁玛瑙摆件

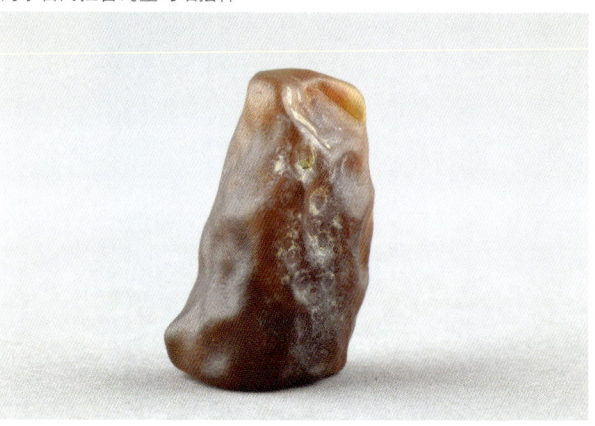

下面让我们来看一下玛瑙主要的价格，但是这个价格只是一个参考。因为本书的价格是已经抽象过的价格，是研究用的价格，实际上已经隐去了该行业的商业机密。如有雷同，纯属巧合，仅仅是给读者一个参考而已。

唐 玛瑙盘：320 万～380 万元

明 玛瑙觥：280 万～380 万元

清 雍正玛瑙碗：280 万～380 万元

清 玛瑙笔舔：0.8 万～2.6 万元

清 玛瑙炉：2 万～6 万元

清 玛瑙随形章：0.6 万～0.8 万元

清 玛瑙挂件：4 万～6 万元

清 南红玛瑙马：5 万～8 万元

清 玛瑙洗：0.6 万～0.8 万元

清 黄玛瑙瓶：3 万～8 万元

清 翠、玛瑙龙纽、兽纽印章：
　2 万～5 万元

清 紫檀南红玛瑙盖：3 万～6 万元

清 玛瑙俏色坠：0.8 万～1.8 万元

清 玛瑙佩：0.6 万～1 万元

清 玛瑙水晶山子：8 万～10 万元

清 玛瑙摆件：8.6 万～18 万元

清 玛瑙烟壶：0.4 万～1.5 万元

清 南红杯：0.8 万～0.9 万元

清 南红笔架：0.5 万～0.8 万元

清 南红镇：8.8 万～9.8 万元

清 南红洗：12 万～18 万元

清 南红笔舔：6.8 万～8.8 万元

清 南红鱼纹：1.6 万～2.6 万元

清 南红山子：3 万～5 万元

清 南红摆件：8.7 万～18 万元

清 南红人物坠：4.8 万～6.6 万元

清 南红串：0.5 万～0.8 万元

清 南红烟壶：0.7 万～8.8 万元

清 紫檀嵌南红镇：2.6 万～4.8 万元

清 南红小瓶：2.2 万～3.7 万元

清 南红如意坠：2.3 万～3.8 万元

清 南红花插：2.2 万～2.8 万元

民国 玛瑙香炉：0.3 万～0.6 万元

民国 南红摆件：5 万～8 万元

民国 南红佩：0.5 万～0.8 万元

当代 南红三颗配松石隔珠项链：
　2 万～3.6 万元

当代 南红配松石隔珠项链：
　2.8 万～3.2 万元

当代 南红朝珠：0.42 万～0.65 万元

当代 南红、蓝宝手串：
　0.68 万～0.78 万元

当代 白玉配南红手串：
　0.5 万～0.8 万元

当代 南红 108 颗佛珠：
　300 万～360 万元

当代 南红十五籽念珠：
　1.6 万～2.8 万元

当代 南红川料 108 粒佛珠：
　5.6 万～8.8 万元

当代 南红项链：0.56 万～0.88 万元

当代 玛瑙山水摆件：
　0.6 万～0.90 万元

当代 玛瑙、粉晶项链：
　0.28 万～0.38 万元

二、砍价技巧

砍价是一种技巧，但它不是根本性的商业活动。它的目的就是与对方讨价还价，找到对自己最有利的因素。但从根本上讲砍价只是一种技巧，理论上只能将虚高的价格谈下来，但当接近成本时显然是无法真正砍价的。所以，忽略玛瑙的时代及工艺水平来砍价，结果可能不会太理想。通常，玛瑙的砍价主要有这几个方面。

一是品相，玛瑙在经历了岁月长河之后大多数已经残缺不全，但一些好的玛瑙今日依然是可以完整保存，正如我们在博物馆看到的商周时期的玛瑙一样，熠熠生辉，映出人影。但从实践中我们也可以看到一些玛瑙的确是损失惨重，这样即使再古老的玛瑙也会影响其价值。因此，残缺自然也就成为了砍价的利器。

二是时代，玛瑙的时代特征对于玛瑙的价格影响是巨大的，因为毕竟古代玛瑙承载着众多的历史信息，是历史的见证者，具有史实的价值，会随着研究的深入，价值不断增加。所以，老玛瑙的价值一般大于同类别新开采出来的玛瑙价值，特别是反应在价格上更是如此，所以，很多玛瑙制品在销售时，其年代都是往古代玛瑙上靠，其实它们可能根本不到代，个别是过代。所以要仔细观察，如果找到时代上的瑕疵，则必将成为砍价的利器。

三是品类，玛瑙特别讲究品类。如南红自然高于普通玛瑙的价格，同样战国红也是这样。所以，买玛瑙要讲品类，因此找到品类，特别是具体产地上的瑕疵，是抢锤砸价的重要方面。

图战国红摆件

南红凉山料圆珠

战国红摆件

马达加斯加红玛瑙执壶（三维复原色彩图）

四是精致程度，从精致程度上看，玛瑙的精致程度是每一个品类的玛瑙都具有的，同时在做工上也有精致程度之分。二者合二为一，玛瑙便可以分出精致、普通、粗糙三个等级。那么，其价格自然也是根据等级参差不同。所以，将自己要购买的玛瑙纳入相应的等级，这是砍价的基础。

总之，玛瑙的砍价技巧涉及时代、做工、造型、纹饰、大小、净度等诸多方面，从中找出缺陷，必将成为砍价利器。

战国红摆件

玛瑙摆件

第三节 懂保养

一、清 洗

清洗是收藏到玛瑙之后很多人要进行的一项工作，目的就是要把玛瑙表面及其断裂面的灰土和污垢清除干净。但在清洗的过程当中，首先要保护玛瑙不受到伤害。一般不采用直接放入水中来进行清洗，因为自来水中有多种矿物质，可能会使玛瑙表面受到伤害。通常是用纯净水进行清洗。可以用软毛的刷子，也可以用肥皂进行清洗。待到土蚀完全溶解后，再用棉球将其擦拭干净。遇到未除干净的剔污垢，可以用牛角刀进行试探性的剔除。如果还未洗净，请送交专业修复机构进行处理，千万不能强行剔除，以防损伤、划伤玛瑙。

玛瑙摆件

南红凉山料摆件

南红凉山料摆件

南红凉山料摆件

二、修 复

历经沧桑风雨，大多数古代玛瑙需要修复。主要包括拼接和配补两部分，拼接就是用黏合剂把破碎的玛瑙片重新黏合起来。拼接工作十分复杂，有时想把它们重新黏合起来也十分困难。一般情况下主要是根据共同点进行组合，如根据碎片的形状、纹饰等特点，逐块进行拼对，最好再进行调整。配补只有在特别需要的情况下才进行，一般情况下拼接完成就已经完成了考古修复。只有商业修复需要将玛瑙配补到原貌。

三、防止磕碰

中国古代玛瑙在保养中最大的问题就是防止磕碰。因为古玛瑙在历经数千年岁月长河之后，非常的脆弱，稍有不慎，一些片雕的作品就会断开，对文物造成不可弥补的损失。那么，在这一情况下，防止磕碰最主要的一点就是对待古玛瑙的态度一定要慎重，在把玩和移动时要事先做好预案。举一个博物馆的例子，就是有些博物馆内收藏的玛瑙几年甚至十几年不移动的情况很常见。其次就是在把玩和欣赏时要轻拿轻放，一般情况下要在桌子上铺上软垫，防止玛瑙不慎滑落。再者就是独立包装，单独存放，这样可以最大限度地保护玛瑙，防止磕碰。

四、禁止暴晒

暴晒是玛瑙保养的禁忌。玛瑙不能长时间的被阳光照射，这样会使玛瑙温度迅速升高，反复的热胀冷缩会导致玛瑙内部开裂，原有的裂纹也会随之增大。同时也要防止玛瑙被放置在距离火炉或者明火近的地方，烘烤可以使玛瑙在色彩上有很大的变化。

马达加斯加红玛瑙碗（三维复原色彩图）

五、日常维护

玛瑙日常维护的第一步是进行测量，对玛瑙的长度、高度、厚度等有效数据进行测量。目的很明确，就是对玛瑙进行研究，以及防止被盗或是被调换。第二部是进行拍照，如正视图、俯视图和侧视图等，给玛瑙保留一个完整的影像资料。第三步是建卡，收藏当中很多机构，如博物馆等通常给玛瑙建立卡片。卡片登记内容如名称，包括原来的名称和现在的名称，以及规范的名称；其次是年代，就是这件玛瑙的制造年代、考古学年代；还有质地、功能、工艺技法、形态特征等的详细文字描述。这样，我们就完成了对古玛瑙收藏最基本的工作。第四步是建账，机构收藏的玛瑙，如博物馆通常在测量、拍照、卡片、包括绘图等完成以后，还需要入国家财产总登记账，和分类账两种，一式一份，不能复制，主要内容是将文物编号，有总登记号、名称、年代、质地、数量、尺寸、级别、完残程度，以及入藏日期等。总登记账要求有电子和纸质两种，是文物的基本账册。藏品分类账也是由总登记号、分类号、名称、年代、质地等组成，以备查阅。

南红凉山料摆件

绿玛瑙摆件

红玛瑙摆件

红玛瑙摆件

阿拉善戈壁玛瑙执壶（三维复原色彩图）

六、相对温度

玛瑙的保养，室内温度也很重要，特别是对于经过复原的玛瑙，温度尤为重要。因为一般情况下，黏合剂都有其温度的最高界限，如果超出就很容易出现问题。一般库房温度应保持在 20 ~ 25℃较为适宜。

七、相对湿度

一般情况下，中国古代玛瑙的相对湿度应保持在 30% ~ 70% 之间，因为如果相对湿度过大，玛瑙容易形成沁色侵蚀，这对保存玛瑙不利。同时也不易过于干燥。但总的来说，玛瑙对于湿度的要求并不高。

绿玛瑙摆件

绿玛瑙执壶（三维复原色彩图）

第四节　市场趋势

一、价值判断

　　价值判断就是评价值。我们所作的很多的工作，就是要达到能够评判价值。在评判价值的过程中，也许一件玛瑙有很多的价值，但一般来讲我们要能够判断玛瑙的三大价值，即玛瑙的研究价值、艺术价值、经济价值。当然，这三大价值是建立在诸多鉴定要点的基础之上的。研究价值主要是指在科研上的价值，如透过中国古代玛瑙上所蕴含的历史信息，可以使我们看到不同时代发达的科学技术水平，以及人们生活的点点滴滴。因为玛瑙的硬度非常大，而我国在新石器时代就能够琢磨、利用玛瑙，或作为农具，或作为装饰品等，总之，具有很高的历史研究价值等，这些都是研究价值的具体体现，对于历史学、考古学、人类学、博物馆学、民族学、文物学等诸多

红玛瑙卧狮·清

马达加斯加红玛瑙算珠

水草花玛瑙筒珠

组玉佩·西周

领域都有着重要的研究价值，日益成为人们关注的焦点。而玛瑙的
艺术价值就更为突出，早在商周时期，玛瑙就经过焙烧与玉器结合，
成为大型玉礼器的组件。如西周虢国国君墓出土的五璜联珠组玉佩
和七璜联珠组玉佩等，象征权力与地位。当代人们更是将玛瑙细化
为诸多种类，如南红、战国红等。将这些玛瑙中的优质料，雕刻琢
磨成精美绝伦的艺术品，在造型艺术、纹饰艺术、色彩艺术、书法
艺术等诸多方面成就极大，都是同时代艺术水平和思想观念的体现，
具有较高的艺术价值。而我们收藏的目的之一就是要找到和发现这
些艺术价值。另外，玛瑙具有很高的经济价值。当然，玛瑙的经济
价值主要是在其研究和艺术价值的基础之上出现的，且研究价值、
艺术价值、经济价值互为支撑、相辅相成，呈现出的是正比的关系。
研究价值和艺术价值越高，经济价值就会越高，反之经济价值则逐
渐降低。另外，玛瑙还受到品类、琢工、色彩、时代、完残等诸多
要素的影响。

七璜组玉佩下半部（局部）·西周

南红凉山料摆件

红玛瑙执壶（三维复原色彩图）

马达加斯加红玛瑙圆珠

南红凉山料手链

二、保值与升值

玛瑙在中国有着悠久的历史。在新石器时代就已经产生，但真正作为装饰品来普遍使用是在商周时期，特别是西周晚期达至鼎盛。秦汉以降，直至当代，历史上每个不同的历史时期流行的玛瑙都是有所不同。从玛瑙收藏的历史来看，玛瑙是一种盛世的收藏品。在战争和动荡的年代，人们对于玛瑙的追求凤愿会降低，在盛世，人们对玛瑙的情结通常水涨船高，玛瑙会受到人们追捧，趋之若鹜，特别是名品，如保山南红、凉山南红、战国红等。近些年来，股市低迷、楼市不稳有所加剧，越来越多的人把目光投向了玛瑙收藏市场。在这种背景之下，玛瑙与资本结缘，成为资本追逐的对象，高品质玛瑙的价格扶摇直上，升值数十至上百倍。而且这一趋势依然在迅猛发展。

战国红玛瑙隔片

南红云南保山杨柳料

战国红摆件

战国红玛瑙碟（三维复原色彩图）

　　从品质上看，玛瑙对品质的追求是永恒的。玛瑙并非都是精品力作，如南红显然比马达加斯加玛瑙要贵重不知多少倍，比一般的红玛瑙也要贵重，因此高品质的玛瑙具有很强的保值和升值价值。

　　从数量上看，对于玛瑙而言已是不可再生。如南红保山料几乎很难再有大的开采量，"物以稀为贵"，具有了很强的保值、升值的功能。

战国红摆件

　　总之，玛瑙的消费量特别大。人们对玛瑙趋之若鹜，特别是精品玛瑙不断爆出天价，被各个国家收藏者所收藏，且又不可再生，所以"物以稀为贵"的局面将会也越发严重。玛瑙保值、升值的功能将会进一步增强。

南红凉山料摆件

南红凉山料摆件

战国红镯（三维复原色彩图）

参考文献

[1] 广西壮族自治区文物工作队，合浦县博物馆.广西合浦县九只岭东汉墓 [J]. 考古 ,2003(10).

[2] 成都市文物考古工作队.四川崇州市双河史前城址试掘简报 [J]. 考古 ,2002(10).

[3] 广西壮族自治区文物工作队、那坡县博物馆.广西那坡县感驮岩遗址发掘简报 [J]. 考古 ,2003(10).

[4] 上海博物馆考古研究部.上海金山区亭林遗址 1988、1990 年良渚文化墓葬的发掘 [J]. 考古 ,2002(10).

[5] 安徽省文物考古研究所，含山县文物管理所.安徽含山县凌家滩遗址第三次发掘简报 [J]. 考古 ,1999(11).

[6] 姚江波.中国古代铜器鉴定 [M].长沙：湖南美术出版社 ,2009.

[7] 王大有，宋宝忠，王双有.奥尔梅克拉文塔第四号文物玉圭铭文解读 [J]. 寻根 ,2000(5):80.

[8] 姚江波.文物鉴赏 [M].北京：中国人民大学出版社 ,2013.

[9] 中国社会科学院考古研究所山东工作队.山东滕州市前掌大商周墓地 1998 年发掘简报 [J]. 考古 ,2000(7).

[10] 河南省考古研究所，三门峡市文物队.三门峡虢国墓 [M].北京：文物出版社 ,1999.

[11] 周庆喜.宁夏彭阳县张街村春秋战国墓地 [J]. 考古 ,2002(8).

[12] 淄博市博物馆.山东淄博市临淄区南马坊一号战国墓 [J]. 考古 ,1999(2).

[13] 中国社会科学院考古研究所四川工作队，松潘县文物管理所．四川松潘县松林坡唐代墓葬的清理 [J]. 考古 ,1998(1).

[14] 西藏自治区山南地区文物局．西藏浪卡子县查加沟古墓葬的清理 [J]. 考古 ,2001(6).

[15] 中国社会科学院考古研究所内蒙古工作队，内蒙古文物考古研究所．内蒙古扎鲁特旗浩特花辽代壁画墓 [J]. 考古 ,2003(1).

[16] 黑龙江省文物考古研究所．黑龙江东宁县小地营遗址渤海房址 [J]. 考古 ,2003(3).

[17] 南京市博物馆．江苏南京市明黔国公沐昌祚、沐睿墓 [J]. 考古 ,1999(10).

[18] 河北省文物研究所，邢台市文物管理处．河北邢台市葛家庄 10 号墓的发掘 [J]. 考古 ,2001(2).

[19] 广西壮族自治区文物工作队．广西贵港市马鞍岭东汉墓 [J]. 考古 ,2002(3).

[20] 姚江波．中国古代玉器鉴定 [M]. 长沙：湖南美术出版社 ,2009.

[21] 山东大学考古系．山东长清县仙人台周代墓地 [J]. 考古 ,1998(9).

[22] 扬州博物馆．江苏邗江县姚庄 102 号汉墓 [J]. 考古 ,2000(4).

[23] 广州市文物考古研究所．广州市横枝岗西汉墓的清理 [J]. 考古 ,2003(5).

[24] 老河口市博物馆．湖北老河口市李楼西晋纪年墓 [J]. 考古 ,1998(2).

[25] 长沙市文物考古研究所．长沙市马益顺巷一号楚墓 [J]. 考古 ,2003(4).

[26] 广西文物工作队，合浦县博物馆．广西合浦县母猪岭东汉墓 [J]. 考古 ,1998(5).

[27] 闫永福．河北张北县一带的细石器遗存 [J]. 考古 ,2001(3).

[28] 马清鹏．河北滦平县药王庙梁遗址调查 [J]. 考古 ,1998(2).

[29] 苏州博物馆，昆山市文化局，千灯镇人民政府．江苏昆山市少卿山遗址的发掘 [J]. 考古 ,2000(4).

[30] 中国社会科学院考古研究所洛阳唐城队．河南洛阳市中州路北东周墓葬的清理 [J]. 考古 ,2002(12).

[31] 辽宁省文物考古研究所，本溪市博物馆桓，仁县文物管理所．辽宁桓仁县高丽墓子高句丽积石墓 [J]. 考古 ,1999(4).

[32] 黑龙江省文物考古研究所．黑龙江双鸭山市保安村汉魏城址的试掘 [J]. 考古 ,2003(2).

[33] 郭珉．吉林大安县后宝石墓地调查 [J]. 考古 ,1997(2).

[34] 中国社会科学院考古研究所，日本奈良国立文化财研究所，中日联合考古队．汉长安城桂宫四号建筑遗址发掘简报 [J]. 考古 ,2002(12).

[35] 南京市博物馆．江苏南京市板仓村明墓的发掘 [J]. 考古 ,1999(10).

[36] 湖南省文物考古研究所，永州市芝山区文物管理所．湖南永州市鹞子岭二号西汉墓 [J]. 考古 ,2001(4).

[37] 云南省文物考古研究所，玉溪市文物管理所，江川县文化局．云南江川县李家山古墓群第二次发掘 [J]. 考古 ,2001(12).

[38] 姚江波．西周青铜器鉴定 [N]. 中国文物报 ,2004(2).

[39] 湖南省文物考古研究所．湖南安乡县划城岗遗址第二次发掘简报 [J]. 考古 ,2001(4).

[40] 青海省文物管理处，青海省海南藏族自治州民族博物馆．青海同德县宗日遗址发掘简报 [J]. 考古 ,1998(5).